# VISUAL DESIGN ON THE COMPUTER

S E C O N D   E D I T I O N

| | DATE DUE | ✓ |
|---|---|---|
| | | |
| | | |
| | | |
| | | |
| | | |
| | | |
| | | |
| | | |
| | | |
| | | |
| | | |
| | | |

# VISUAL DESIGN ON THE COMPUTER

SECOND EDITION

## WUCIUS WONG & BENJAMIN WONG

W. W. NORTON & COMPANY

NEW YORK • LONDON

For information about permission to reproduce selections from this book, write to Permissions, W. W. Norton & Company, Inc., 500 Fifth Avenue, New York, NY 10110

The text of this book is set in Garamond
with the display set in Futura
Manufacturing by Quebecor Kingsport
Book design by Wucius Wong
Production manager: Leeann Graham

**Library of Congress Cataloging-in-Publication Data**
Wong, Wucius
  Visual design on the computer / Wucius Wong & Benjamin Wong.—2nd ed.
    p. cm.
    Includes index.
  **ISBN 0-393-73061-1** (pbk.)
    1. Computer-aided design. I. Wong, Benjamin. II. Title.

TA174 .W588 2001
745.4—dc21                                                      2001030912

W. W. Norton & Company, Inc., 500 Fifth Avenue, New York, NY 10110
www.wwnorton.com
W. W. Norton & Company Ltd., Castle House, 75/76 Wells Street, London W1T 3QT

0 9 8 7 6 5 4 3 2 1

TO PANSY

The first edition of this book was published in 1994, a time when the computer had been recognized as a general tool for design. Since then, in a short span of eight years, escalated advancement in technology has made the computer a standard piece of equipment for people in all walks of life.

We are undoubtedly in a full-fledged Information Age. Most of us turn on the computer everyday for one reason or another, to organize our daily chores, access information, communicate with others around the world, aid us in decision-making—not to mention those of us whose jobs are computer-reliant.

While the general techniques have remained more or less the same, *designing* on the computer has become more versatile, and we can now produce more elaborate results with simpler operations.

Apart from design students who learn to use the computer for design purposes as part of their basic training, most people love to design simple items on the computer, which they print out immediately, with pleasing results.

There is a need for the type of book that can help *anyone* learn how to design on the computer—a book that not only introduces the basic techniques of operation to create lines and shapes, but also provides easy-to-follow instructions for exploring immediately satisfying ways of designing documents and other visual items tangibly printed as hard copies.

In seeking a totally fresh approach to tackle this need, we have almost completely rewritten this book with hundreds of new diagrams and illustrations.

**8**

Special features in this revised edition include:

1. The chapters form a self-contained course and progress from simple to more complex subjects and procedures.

2. Starting with Chapter 3, each chapter introduces a new aspect or concept in visual design, with related technical requirements and practices.

3. Illustrated step-by-step descriptions accompany each essential operation.

4. The reader can follow the detailed explanations to redo the examples and attempt suggested exercises at a self-determining pace.

5. The last chapter in the book provides guidance to print and assemble all work in the form of a leaflet or bound book for readers' personal portfolios.

Only the simplest setup in computer hardware and software in either Macintosh or PC platform is required, plus a color printer and a scanner. Software should include a draw program to produce lines and shapes and, if possible, an image-editing program to handle photographs and scanned images.

This edition can be used by design teachers to organize a basic design course, because it covers all the fundamental vocabulary and grammar constituting a new visual language that blends with computer language. Finally, professional designers may find that many of the concepts and examples stimulate their creative thinking.

# C O N T E N T S

12

INTRODUCTION

Generally speaking, designing is a kind of structured activity whose aim is to discover a valid, efficient, cost-effective, and visually satisfying solution (a design) to a pre-established problem.

Design products can be two-dimensional—they can be drawn, painted, or printed on paper, fabric, or any type of flat surface—or three-dimensional—they can be manufactured or assembled in any suitable material. A design can even incorporate light, sound, and movement or form an environment by itself.

At one end of the design spectrum is its functional aspect, which involves practical needs, budgets, and production processes, and the exacting demands of communication and other directives. In daily reality, the designer is a problem-solver who often works with other experts in a team.

At the other end, there is the visual aspect of design, which involves the creation and arrangement of shapes, patterns, and possibly textual elements. For this aspect—attaining a high standard of visual accomplishment—the designer always assumes full responsibility.

## VISUAL DESIGN

Our prime objective is to present an analysis of the basic visual language and its application to design creation on the computer.

In this chapter, we shall review the general vocabulary and grammar of visual design and examine various stages and methods of the actual designing process. Our demonstrations and suggested experiments are generally limited to two-dimensional designs in black and white and the grayscale that can be printed inexpensively on paper. A color section explores a sampling of color theories and provides color illustrations.

## AESTHETIC ORGANIZATION

In most cases, visual design is no more than aesthetic organization.

Basic elements such as dots, lines, curves, squares, rectangles, triangles, polygons, circles, ellipses, letters, numbers, symbols, and so on are often the ingredients for compositions. Aesthetic organization involves the choice of appropriate elements, as well as decisions concerning their specific dimensions, colors, shades, textures, positions, and directions.

## DECORATION

**16**

Visual design that consists of repeated motifs that accentuate, surround, or cover an entire surface may be seen as decoration.

A decorative design must attract or please the eye and enhance the appearance of the surface it adorns.

Such a design can be a self-contained entity; a continuous band, border, or frame; a vignette; or an overall pattern.

If the motif comes from a particular source, the design may have cultural or historical references.

## SELF-EXPRESSION

Visual design is not always decorative. As a form of self-expression it can convey a specific feeling, emotion, mood, or impression.

For instance, a geometric design might reflect the spirit of this technological era. Scattered fragments in a composition might suggest a mind searching for a new sense of order. Blurred shapes might suggest movement and speed.

Visual design can become art when it is the result or revelation of a highly individualistic endeavor.

## COMMUNICATION

Visual design can communicate a message when it incorporates words, symbols, or representational shapes that are readily understood by the viewer.

Words may have definite meanings. Symbols may have clear associations. Representational shapes may be based on physical objects and observable phenomena in our daily experience. Abstract shapes that express feelings and emotions may also form part of visual communication.

When we deal with visual forms of communication, our concern may include conveying messages, explaining ideas and thoughts, providing guidance and direction, persuasion, and stimulation of emotions; all of these constitute the functional aspect of design.

## THE DESIGNING PROCESS

The experiments in visual design demonstrated here or suggested for individual attempts may have no obvious commercial intent or any practical application. They do help readers, however, to develop visual thinking, a good aesthetic sense, as well as a methodical approach to achieve their specific design goals.

Any design must start with an understanding of what is required by a given problem, and end with a valid solution to the problem. Systematic thinking, a willingness to explore all possibilities, and the ability to make proper decisions at the right moments are all required qualities for a designer.

The designing process generally includes identification of the goal, interpretation of given specifications, preliminary research, development of ideas, eventual realization of the design, and final refinement. Planning a work schedule and observing time parameters are also essential.

## THE DESIGN PROBLEM

## THE GOAL

**1 8**

In visual design a problem could consist of a simple exercise, such as creating a new shape or composition, or changing an existing shape or composition by considering all possible variations and being able to choose the right one.

Creating a new shape or composition on a computer undoubtedly requires prior understanding of certain techniques. Conformity to predetermined specifications and conditions set by the problem are essential.

Any design problem must have a goal. The main goal of the suggested exercises at the end of each chapter is for the reader to demonstrate an understanding of particular design concepts discussed at definite stages.

There are also secondary goals. In the context of this book, supplementary goals of the suggested exercises include development of artistic sensitivity and skills in using computer software programs to attain required effects.

## SPECIFICATIONS

Specifications are noted for each design problem, such as the overall dimensions and quantity of work, elements to be used for creating shapes and compositions, methods or techniques to be used, theme or subject matter, and/or message to be conveyed.

Such specifications must be strictly followed; they determine what should, and should not, be done. However, there is also room for personal interpretations. Setting a timetable for completing the exercises is recommended.

## PRELIMINARY RESEARCH

Design problems that are just simple exercises may not require preliminary research work. Certainly studying how to use relevant tools and commands in a software manual, or in a help folder of the program, is always necessary before working on any design problem.

In other instances, problems that call for materials with social, historical, or cultural references may require the designer to seek out, find, and sort the necessary information. Such visual information could be obtained from books or by visiting special locations.

## IDEAS AND METHODS

**20**

Preliminary research also includes browsing through design books and magazines and looking for examples of solutions to similar problems or for sources of inspiration. A designer should always be aware of current trends and rejuvenated styles and on the alert for new ideas and methods.

Although straightforward imitation should be discouraged, imitation with modifications is often a part of the learning process. Ideas and methods do not germinate from nothing, after all, but are developed from, or as reactions to, existing ideas and methods.

There are several levels of formulating and implementing ideas and methods during the designing process. On the conceptual level, we seek a fresh approach to the problem. On the visual level, we attempt to create a unique composition. On the technical level, we consider the use of unusual materials and processes in design production.

## EXPLORATION

The actual design process starts with visual exploration of the preliminary ideas. This can be in the form of pencil sketches or the computer's equivalent: whatever comes to mind is visualized, with no concern for details and proportions.

At the final stage, one of the experiments is chosen as the best solution to the problem and then rendered with full conformity to the specifications set by the design problem.

## REFINING THE DESIGN

Mere conformity to preset specifications does not necessarily create good design. The design should have a high standard of visual appeal, which is determined by the configuration, size, proportion, colors, and other visual attributes of individual shapes, as well as the overall organization of the elements in terms of their contrasts and harmonizing relationships.

Any design problem can have more than one appropriate answer. Any appropriate answer can have more than one version. Refining a design can be done by making slight changes in one or another. Sometimes a minute change makes considerable difference in the visual appearance.

## PRESENTATION

The presentation stage is the conclusion of the design process, when the results of tackling a given problem are ready to be seen by other people.

The design should be in a highly finished form for presentation. A general practice is to print the design on high-quality paper and then trim as needed. Cutting of additional shapes, folding, gluing, and joining might also be necessary.

## EVALUATION

**22**

Whether a design is visually satisfying is largely determined by subjective preferences. Evaluation of the same design as a valid solution to a particular problem, however, can involve a more objective process. The following questions may be helpful for self-learners or teachers to establish a set of criteria:

- Has the design met the deadline?
- Does the design incorporate all given specifications?
- Does the design contain all necessary information?
- Did the designer understand the problem or reach the goal?
- Did the designer provide a unique solution to the problem?
- Does the design show a high standard of visual accomplishment?
- Is there room for further improvement?

The above are arranged in a descending order of importance and reflect the discipline of the design profession. Although there are different levels of achievement possible for each point, positive answers are generally expected.

## SETTING PROBLEMS

Suggested exercises in this book may be modified or replaced to suit individual requirements. If the self-learner or teacher wants to create alternative problems, the following checklist can be used as a guide. Provide the following information:

- The goal
- Specifications for subject matter or theme
- Specifications for information to be included
- Specifications for visual requirements
- Specifications for dimensional requirements
- Specifications for technical requirements
- Specifications for printing and post-printing treatment
- Specifications for the procedural requirements
- Specifications for quantity and range of work
- Suggestions and preferences
- Evaluation criteria
- The deadline

E Q U I P M E N T

2

**24**

In conventional practice visual design has been created using pencil, marker, pen with ink, brush with paint, or airbrush with liquid color, along with drawing board, T-square, protractor, ruler, triangles, compasses, French curves, and flexible curve-guides.

This method has distinct advantages, for we are dealing with actual tools, along with physical materials and media, and the shapes created have a tactile presence. In addition, we can improve our drawing abilities as we develop our design skills.

The conventional method has distinct disadvantages, however. The accurate rendering and arrangement of shapes can be extremely time-consuming. Even a small change might call for a major revision or a complete redoing from scratch. Less work is accomplished with greater effort, and the entire process—the attainment of finished work—is slow.

Now most of such work can be done on the computer with comparable or even better results. The computer not only offers efficiency and precision, it also opens a new horizon in visual creation. It makes learning visual design easier within a much shorter time span.

## THE COMPUTER REVOLUTION

The computer is a machine that works with electronic signals. It was first invented to calculate complex figures and formulas and to sort data. Later developments in computer technology vastly extended its capabilities, making the computer useful for all kinds of human needs and enabling the machine to complete otherwise tedious manual tasks quickly, easily, and reliably.

Formerly occupying an entire room, the computer has shrunk drastically in size over the decades. Its price has also decreased to the extent that the computer has gradually become standard equipment in offices, homes, and schools.

## THE NEW VISUAL LANGUAGE

Understanding the computer and working with it effectively require a thorough acquaintance with its special language—and in its full technical range, this computer language can be very complex.

For a general user, computer language might not seem that complicated because only a set of simple rules and commands may be needed to achieve the specific results desired by the user.

For the designer, this language primarily comprises methods and procedures for originating lines, shapes, and type, which are available to us in desired colors, shades, and patterns, at the click of a finger or with slight movement of the palm. Furthermore, their alignment, distribution, duplication, and transformation can be done almost instantly.

In the Information Age, we all have to deal with a new visual language—by which our traditional principles of design may have to be completely redefined.

## COMPUTER HARDWARE

To tackle this new visual language, we need to become acquainted with computer equipment (which we may have to acquire on our own).

For home and office use, computer equipment generally falls into two main categories. There are the IBM-compatibles, or what is generally referred to as the PCs (personal computers), made by many manufacturers. There are also the Macintoshes, manufactured solely by Apple Computers, Inc.

Differences between the two systems are gradually diminishing and may soon be completely eliminated. Many popular software programs have versions for both systems, with operation techniques that are quite similar.

To ensure speed and efficiency, computers for design use should have a relatively larger RAM (random access memory) in their central processing unit than what is normal for ordinary use. The built-in hard drive should have generous room for storage to accomodate file sizes that are only getting larger and larger with new, improved versions of software programs.

Other pieces of equipment needed for a modest start are an inkjet printer and a flat-bed scanner that is capable of handling works of full color no smaller than letter, legal, size or metric A4 size.

## COMPUTER SOFTWARE

A computer cannot accomplish anything without relevant software. Software refers to programs pre-recorded on CD-ROMs for installation on the computer's internal hard drive.

Different programs serve different purposes. Word-processing, spreadsheet, and database programs satisfy the needs of most people. Graphics programs are used by designers.

Graphics programs fall into several classifications: drawing, painting, image-editing, page layout, font manipulation, three-dimensional rendering, and special display and transmission requirements for Web sites.

A program usually comes with a printed manual that explains the techniques and procedures particular to the program. A tutorial book with a step-by-step guide to help the user might also be part of the program package. In addition, convenient online help to provide instant guidance for users is often available.

## THE MONITOR SCREEN

The *central processing unit* is the heart of the computer, and it is completely hidden from view. Verbal, numerical, and visual information is transmitted to our eyes through the *monitor*, which effects the display of images on a screen.

Once the computer is started, a startup menu bar may occupy the top of the screen. The lit-up screen represents the *desktop* with an array of *icons* or symbols representing the disk drives, folders, programs, files, and documents available for use. If the icon depicts a folder, clicking on it reveals its contents, which could be other folders nested inside it, or applications, files, or documents.

Clicking or double-clicking on the icon or name representing the application launches the program, and a *document window* appears on the desktop, functioning as a piece of paper for image creation and display. A special menu bar associated with the program replaces the startup menu bar and shows a row of *menu heads*, each containing a list of *commands* for specific tasks. There could also be a range of visual buttons for shortcut commands.

## THE KEYBOARD

Essential components directly connected to the central processing unit comprise the *keyboard* and the *mouse*. They are the main input devices in computer operation.

A computer keyboard is similar to that of a typewriter, with almost identical rows of keys for typing characters. There are, however, a number of special keys, positioned at the lower part of the keyboard; when combined with other keys, they effect shortcuts and changes. A set of four arrow keys move selected elements on the screen. A numerical pad may also be present for entering and calculating numbers and other functions. An extended keyboard also contains a row of function keys bordering the top of the keyboard for expediting work.

## THE MOUSE

The mouse is a small, movable, palm-size unit. A standard mouse has a ball underneath its casing and one or more "buttons" at the top. Moving the mouse on a rubber or vinyl pad rolls the ball and concurrently moves a *cursor* on the screen. The cursor represents the location and tracking of the mouse.

Generally, the mouse cursor is used for insertion of text and for selecting commands from the menu bar. In graphics programs, the cursor can select and activate elements as well as modify and transform them. It can also represent pen, pencil, or brush to create lines and shapes.

After moving the cursor to a desired location, we accomplish specific tasks by quickly clicking the mouse's button once or twice or firmly depressing it and *dragging* the mouse in a direction.

## TOOLBOX AND PALETTE

The mouse cursor shifts into an arrow shape to access commands in all programs and to select a particular *tool* in a *toolbox* that may appear on the monitor screen.

The toolbox is a compartmentalized rectangular box containing pictorial symbols, each of which represents a special tool for drawing, painting, or image manipulation.

After clicking on a tool, the cursor changes shape, indicating that it is ready for performing the task specific to the tool.

A tool may be associated with a *palette* on display. A palette is in the shape of a narrow strip or box and shows a range of options, such as shades, colors, patterns, textures, or just a list of descriptive words. How a tool works is affected by the option chosen in the palette.

## DIALOG BOX AND INFORMATION BAR

## DRAW PROGRAMS

Selecting a command under a menu head or double clicking on a tool in the toolbox may activate the display of a *dialog box*, which offers further choices and facilitates numerical entries for precise operation.

An *information bar* may be on constant display to show the coordinates of the mouse cursor or locations, measurements, angles, and movements of one selected element or shape. This becomes a *control bar* or *control palette* if it provides options or permits entries for making instant changes. In certain programs the bar sometimes also takes the shape of a box.

Draw programs produce *vector graphics:* straight lines and curves defined by mathematical quantification called vectors.

**29**

Lines created with draw programs are always sharply defined, can be broad or fine, and can be in any color or shade. They can enclose space to form shapes.

Objects, as lines or shapes, are all separable. At any time in the process they can be joined and split, grouped and ungrouped. They can also be piled up as layers that can be reshuffled, temporarily hidden from view, or withheld from printing.

In addition, a draw program can originate text that can be elaborately manipulated, and integrate painted or photographic images imported from other programs.

A full-featured draw program allows precise control of lengths, sizes, positions, and directions; facilitates changes in line weights, scales, patterns, textures, colors and shades; and permits instantaneous repetitions and sequential duplications, transformations, and blends.

It contains rulers, guides, and a built-in grid for manual or automatic alignment, as well as numerous tools, panels, palettes, and commands for specific tasks and effects.

## PAINT PROGRAMS

Paint programs are designed to simulate the intuitive way we sketch and paint. They produce *raster images* or *bitmap images*, composed of fine square dots in different shades or colors, with each dot standing for a bit. The dots are referred to as pixels, meaning picture elements.

Computer displays and printers are called *raster devices* because information is presented in a raster, or grid, of dots or lines. There are about 72 dots-per-inch (dpi) on a monitor screen, but high-resolution printers are capable of presenting information as hard copy with over a thousand dpi.

Operation of a paint tool affects an area on screen, producing a mark, a line, a shape, or a blurry patch of color that can cover or fuse with marks or images it overlaps. All fused marks or images are subsequently inseparable, unless they were created on different layers allowed by the program.

Special brush shapes and dry or wet media effects can be chosen for creating painted marks. Painted areas can contain specific textures, such as varying paper grains.

## IMAGE-EDITING PROGRAMS

Image-editing programs are also concerned with raster images. With such programs, we retouch, modify, and transform what is brought to the computer screen via scanners, digital cameras, or other devices.

The images may be photographs, paintings, drawings, or printed pictures and texts. They can be given partial or total adjustment in brightness, contrast, and color balance; they can also be sharpened or blurred and considerably altered with the addition, subtraction, and/or transposition of elements.

The tools in image-editing programs are similar to those contained in paint programs. Thus we can create original painted images in a limited way within image-editing programs. A set of filters is commonly available for texturization, distortion, and specific effects.

## PAGE-LAYOUT PROGRAMS

A page-layout program imports pictorial and typo-graphical elements from other programs and orga-nizes them on a single page or on a sequence of pages.

Pictorial elements—such as illustrations and pho-tographs from draw, paint, or image-editing pro-grams—can be rescaled, cropped, masked, framed, or given new backgrounds.

We can type in page-layout programs to insert text, and we can import texts from word-processing pro-grams. All headlines, body text, and other typo-graphic elements can be edited, given font, size, style, and justification changes, constrained in spe-cially shaped text boxes, and shifted to wrap around pictorial elements.

Page-layout programs are indispensable in desktop publishing work that deals with large amounts of text in multiple pages.

## OTHER GRAPHICS PROGRAMS

Font manipulation programs create customized type, through modification, transformation, and/or distortion of existing typefaces.

Three-dimensional rendering programs create frameworks, from plan and elevation views, that can be rotated spatially from different angles and distances. Frameworks can become objects that are covered with surfaces representing specific materials and illumination.

Some programs fabricate textures and effect unusual transformations. They serve very special-ized purposes and are usually supplementary to the main graphics programs.

There are also programs for designing images that incorporate movements and sound, for animation and special effects which can be used on Web sites.

**31**

## CHOICE OF PROGRAMS

**32**

A program should be acquired only when there is a real and immediate need for it. It is unwise to acquire any program for future use. All programs are periodically upgraded by their manufacturers, and new versions always render older versions obsolete.

Choice of programs depends on the user's essential needs at the time, the program's compatibility with existing equipment, and its interface with other programs. Some programs may seem easy to use but lack real power, whereas others may demand considerable effort to master.

Working with concepts described in this book frequently requires a full-featured draw program for vector graphics. Raster images also form an important part of visual design. Therefore, a good image-editing program to produce painted images, to tackle photographs (or whatever) obtained with a scanner or other devices, or to combine vector graphics and raster images to meet specific aims is also a must-have.

In this book, most of the diagrams and illustrations that are vector graphics have been produced with Macromedia FreeHand™, but Adobe Illustrator® is also used in some instances. For raster images, we generally rely on Adobe Photoshop®. The page-layout has been accomplished with Quark Xpress®. All the operations are on a Macintosh computer.

The programs and the computer platform inevitably determine, to a considerable extent, our descriptions of tools, commands, and technical procedures. The reader may have different choices and therefore have to interpret our descriptions with reference to what is available to him/her.

In any case, descriptions can never be comprehensive, and effects can vary with software versions. Even if the reader cannot understand or master certain techniques at some stages, or finds that certain tools or commands are missing in the programs used, redoing the illustrations and attempting the suggested exercises are always recommended. One can go back to earlier chapters at any point and perhaps make discoveries that are beyond the knowledge and skills of the authors.

**3** STRAIGHT LINES

**34**

We can start our first experiments in visual design by working with straight lines in a draw program.

A straight line is the simplest element in graphics. It represents the shortest distance between two points, each being an *end point* of the line.

End points define the starting and terminating locations of the straight line on the monitor screen and determine the line's length, position, and direction in space.

The line is visible to us because it has visual attributes, which include weight, color, shade, pattern, and texture.

In a draw program, the mouse cursor represents the *pen tool* in the toolbox. We can create a straight line by clicking on a mouse button to effect a starting end point, and click again to effect a terminating end point.

Some draw programs provide a *line* tool for drawing straight lines by dragging the mouse cursor.

Names of tools, descriptions of commands, and methods and procedure vary considerably with different programs. To follow the techniques and procedures described, the reader should become familiar with the program either by looking into the help folder of the program on screen, or browsing relevant parts of the printed manual.

## END POINTS

End points that mark the beginning and the end of a line are indicated by solid or hollow square dots as the line is made (**A**). Their presence indicates that the line is *selected* and ready for the next operation.

To create another line, we need first to deselect the line which still shows the end points. We can reach for the *pointer tool* or *selection tool* in the toolbox and click anywhere away from the selected line. Then we can start creating a new line with the pen tool or the line tool.

Using the pointer tool, we can click on the body of any existing line to reselect it and move it to a different location by dragging it, or by pressing one of the four arrow keys on the keyboard in a slow but precise manner (**B**).

## LENGTH, POSITION, AND DIRECTION

The length of a line is the distance between the two end points. Its position determines how each end point is related to the document window. All such information appears on an inspector panel or control palette, and we can effect changes by altering the numbers shown. Dragging any end point changes the position of the point, the length of the line (**C**), and probably also its direction (**D**).

At the time of creating a new line, we can depress the *shift* key to move it in a vertical or horizontal direction (**E**, **F**), or in 45-degree or 135-degree inclination (**G**).

Any existing line can be rotated in any angle. We can use the inspector panel or control palette to rotate a selected line numerically, or engage the *rotate tool* to click and drag a selected line in any direction visually (**H**).

**3 5**

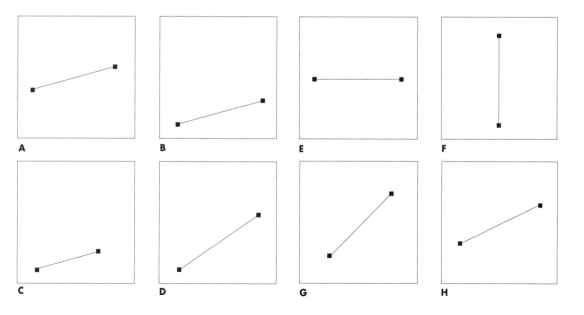

A          B          E          F

C          D          G          H

## WEIGHT OF A LINE

**36**

The weight of a line is gauged in terms of points or fractions of points, which are units of measurement traditionally used in the printing industry. There are 72 points to an inch.

The finest line that can be produced with the computer is a *hairline*, which has the weight of a quarter of a point (**A**). A newly created line has a 1-point weight (**B**), but it can be assigned any appropriate weight by numerical entry in the inspector panel or the control palette (**C**). We can have a line weight of 72 points or more, although we would rarely do so (**D**).

We normally work in a *preview* mode so that we can see all the assigned visual attributes (**E**). Switching to the *keyline* or *artwork* mode (**F**) temporarily changes all lines to black in the weight of a hairline. This enables us to locate particular elements for selection and manipulation.

## COLOR OR SHADE OF A LINE

Besides weight, visual attributes of a line include color or shade, configuration of its ends, and characteristics of its body. All these attributes can be assigned and changed long after its creation.

We can mix a specific color in an available color palette and assign this to a selected line. There are stock colors in color libraries that can be built into the program. Gray shades can be specified in percentages of black (**G**).

Lines in any color or shade are always opaque. A darker line can be obstructed by a lighter line on top of it (**H**). A white line may become invisible on white ground but can be noticed when it is on top of black or gray lines. The layering order of any selected line can be changed with the *bring to front* or *send to back* command.

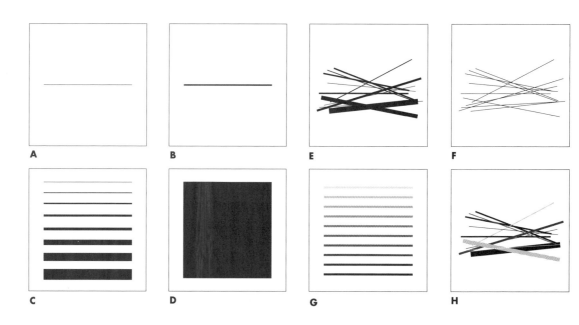

A          B          E          F

C          D          G          H

## ENDS, CAPS, AND ARROW HEADS

The two ends of a line usually appear squared, with no extended caps. These squared ends are referred to as *butt caps* and do not extend the line's length (**A**).

Changing the butt caps into extended caps adds about half of the line's weight to the length of the line at each end. An extended cap can be in a square (**B**) or round configuration (**C**), which gains prominence as the line weight increases.

There may be different configurations of arrow heads, with or without tails, built into a draw program. These can be instantly added to the lines. In this way, the lines become specific shapes (**D**).

Caps and arrow heads increase proportionately in size with increase of line weight and always have the same attributes as the main body of the line. They can add variety in a design (**E**).

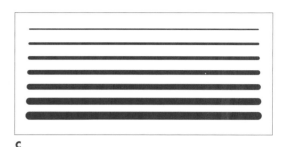

C

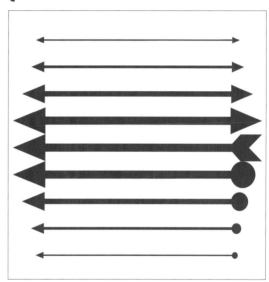

D

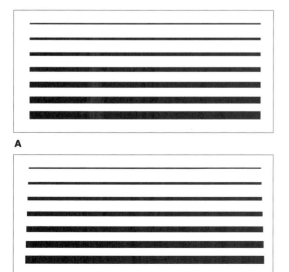

A

B

E

## JOINING AND GROUPING

**3 8**

Two separate straight lines (**A**) can be moved so that the end point of one line coincides with the end point of another line. After the move, they remain noticeably separate if they are in different gray shades (**B**), but they may look connected if they are the same shade (**C**).

To achieve genuine connection, we can use the *join* command to fuse the two elements into one. The result is an angular line with the same visual attributes and a protrusion at the junction (**D**). This protrusion and the shapes of the ends become more prominent with increase of line weight (**E**).

The line now consists of two *segments* that are linked together with a *join*. Configurations of the caps and the join can be changed. We can have round caps with a sharp join (**F**), square caps with a round join (**G**), or square caps with a bevel or truncated join (**H**). Caps for the two end points must always be in the same configuration.

If we move one line so that its one end touches the body of another line, the two lines cannot be properly joined. Instead, we can select them together and use the *group* command to integrate them into a group (**I**).

An integrated group can be moved or rotated as a single entity (**J**), or resized with or without change of proportion (**K**). The group can be duplicated (**L**) or ungrouped to make changes in individual elements and then regrouped (**M**, **N**).

Two or more groups can be further grouped for power duplication (**O**). Further changes and manipulation are always possible with subsequent ungrouping.

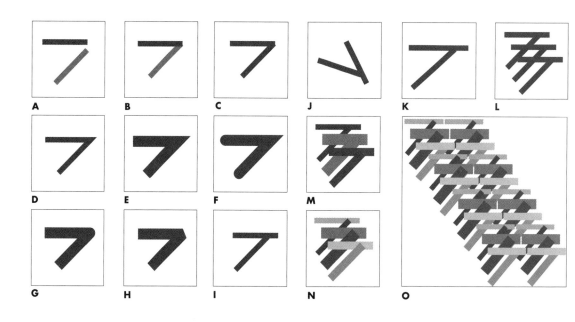

A B C J K L

D E F M

G H I N O

## DASHES

A newly created line is solid and continuous (**A**). There is, however, a *dash* option that can be used to break up the body of the line.

Dashes are short strokes with gaps in between. For any selected line, we can use built-in dash types or specify in a palette the spans of each short stroke and gap in a sequence to obtain a specific dash pattern in a desirable line weight (**B**).

A dashed line can have round caps for each constituent short stroke. In this way, the short strokes can touch or overlap one another (**C**).

Length of a dashed line may require adjustment to allow the short stroke near the end of the line to show its full configuration. Rotating a dashed line or changing its color or shade does not affect the dash pattern (**D**).

## DUPLICATING A LINE

To duplicate a line, we can drag a selected line, depressing the *option* or *alt* key on the keyboard at the same time, to obtain its exact copy and place it anywhere (**E**). Each copy of the line can be assigned different visual attributes (**F**).

We can also use a command to clone the selected line and move the cloned line afterwards. After moving the cloned line to a desired location, we can engage the *duplicate* command to obtain further copies that are spread equidistantly in a definite direction (**G**). This operation, called *power duplication,* can be used many times to form a group in a composition.

Holding down the *shift* key as we drag a cloned line constrains the move to either straight down or straight across. Further duplication can result in a horizontal row or vertical column (**H**).

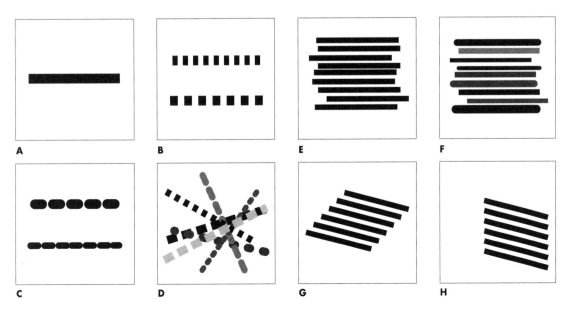

**A**　　　**B**　　　**E**　　　**F**

**C**　　　**D**　　　**G**　　　**H**

## USING WHITE LINES

**40**

We can place a white line on top of another black or color line that is much broader. This makes a slit on the broader line underneath (**A**, **B**).

The two lines can then be selected together and grouped as a unit that is used repeatedly in a composition (**C**, **D**).

To achieve a more complicated composition, we can select these lines and rotate a copy in the vertical direction (**E**). If desirable, we can select all the white lines that are hidden behind and move them to the front layer by using the *send to front* command (**F**).

The white lines can be given round caps and be broken up in a dash pattern (**G**).

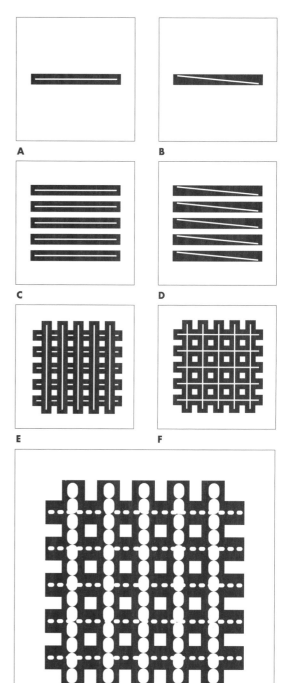

## INTERSECTING LINES

Two straight lines in different directions can intersect one another only at a point.

If both lines are stroked with the same gray shade or color, they seem fused together (**A**). If they are in different grays or colors, the most recently created line appears on top of the one created earlier (**B**).

A group of vertical and horizontal lines intersects with the same effect (**C**). We can send all vertical lines to the back, or bring all horizontal lines to the front, using relevant commands for rearranging their layering order (**D**). We can also send some chosen lines to the back or bring them to the front (**E**).

To achieve a regular woven pattern, we need to add short lines of the same weight and shade on top of the lines that appear behind at certain junctions (**F**).

A grid of thin white lines on top of the woven pattern may add interest to the composition (**G**).

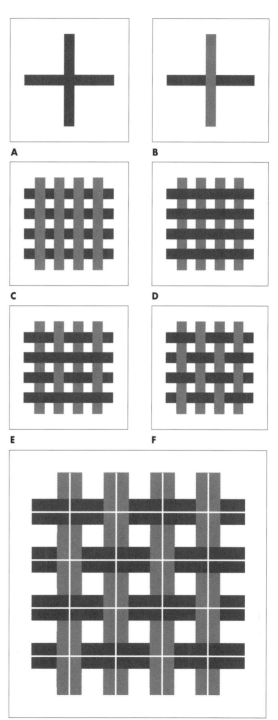

A

B

C

D

E

F

G

## BLENDING LINES

**4 2**

Instead of duplicating a line with repeated transformations, to accomplish similar effects we can blend two lines, one representing the commencing element, the other the terminating element, with a predetermined number of intermediate steps.

The two lines selected for blending can have identical visual attributes (**A**), or they can have different weights (**B**), colors or shades (**C**), lengths (**D**), directions (**E**), or various visual attributes (**F**).

Blending results in an integrated group. Thus all elements in the blend can be collectively rotated (**G**), duplicated (**H**), or resized (**I**).

To perform blending, select the two lines—selection of end points is sometimes necessary—and use a *blend* command. The number of steps in a blend can be numerically entered in a dialog box or inspection panel.

Some draw programs allow us to *subselect* in the blend, with depression of the *option* or *alt* key, either the commencing or the finishing element and to move, rotate, or alter its visual attributes, instantly effecting changes in the entire range (**J**). We can even subselect one of the end points of the commencing or the terminating element to effect changes in the blend.

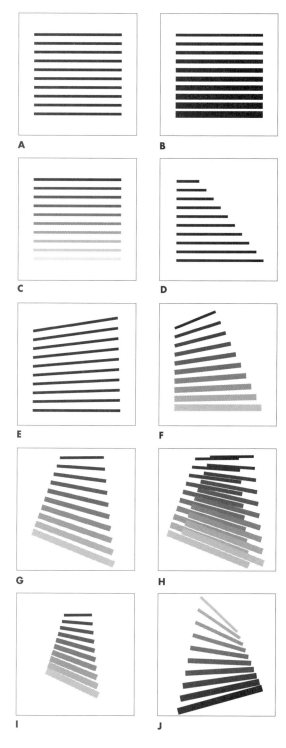

A    B
C    D
E    F
G    H
I    J

## SELECTING AND DESELECTING

Selecting and deselecting techniques are fundamental to all other techniques in any draw program. There may be more than one kind of selection tool, each with a different usage. The reader must become familiar with relevant techniques and procedure before attempting to use other tools.

It is essential to know how to select one entire line, one end point of a line, and more than one line in an operation. Furthermore, we need to know how to *deselect* all that has been selected or just one element among a host of selected elements.

Within an integrated group, we need to know how to subselect one element or more than one element. Any selected or subselected element can be changed or simply deleted by depressing the *delete* key.

## UNDOING AND REDOING

If an operation does not lead to an intended result, we can click on the *undo* command, or press the *command* or *control* key along with the "z" key. This will restore the material that preceded the latest operation. Most draw programs allow undoing of several of the latest operations.

After undoing, if we change our minds and wish to restore the material that preceded the undoing operation, we can undo what has been undone *if there was only one undoing operation*. If there were several sequential undoing operations, we can click on the redo command or press the *command* or *control* key along with the "y" key to effect redoing.

Undoing and redoing can be an effective way for trying out all the different options.

**4 3**

## SUGGESTED EXERCISES

**4 4**

The aim of the exercises suggested here is to rein-force the reader's understanding of the concepts and techniques discussed in the chapter. Before attempting the exercises, the reader can also try to redo illustrations in the foregoing pages.

The following exercises concern designing with straight lines:

•    Launch the application with a new docu-ment window. Create one horizontal line about 3 inches long, 8-point weight, and in black. Drag a copy of it to a position one quarter of an inch (or any desirable dis-tance) directly below it, holding down the *option* or *alt* key and the *shift* key together while dragging. Duplicate the operation seven or more times. Subsequently select alternative lines and change their visual attributes. Use the save command to save the document as **Exercise 1.1**. in an appro-priate folder (**A**).

•    Open the document **Exercise 1.1** and use the *save as* command to resave it as docu-ment **Exercise 1.2** for further operations. Select all the lines and use the *group* com-mand to convert them into an integrated group. Use a related control palette to rotate it 10 degrees. Drag a copy of this group straight down and position it slightly off the original. Send the copy to the back of the original, using the *send to back* command, and change all lines of this copy to a new, lighter shade (**B**).

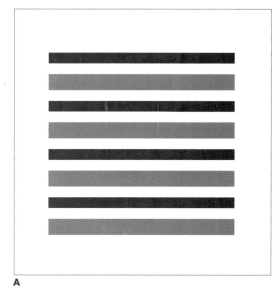

A

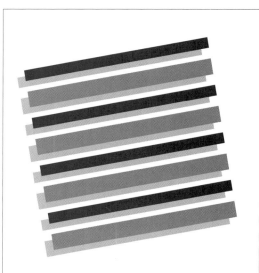

B

• Open the document **Exercise 1.2** and resave it as document **Exercise 1.3** for further operations. Select the front group and rotate it -10 degrees, and then send it to the back. This group now returns to a horizontal position. Select the other group, which now lies in front. Subselect, or select with prior ungrouping, alternative lines and assign them new shades (**C**).

• Open the document **Exercise 1.3** and resave it as document **Exercise 1.4** for further operations. Select all lines and assign them a uniform line weight of 10 points, round caps, and a dash pattern with short strokes and wide gaps (**D**).

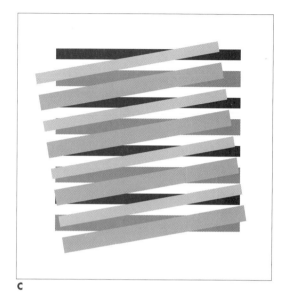

**C**

**D**

**4 6**

• Open the document **Exercise 1.1** and resave it as document **Exercise 1.5** for further operations. Delete all lines except the first line. Drag a copy of this line about 2 inches straight down. Assign the original line a line weight of l0 points and a shade of 90% black, and assign the copy a line weight of 20 points and a shade of 20% black. Select the copy and rotate it -20 degrees. Select the right end point of each line and blend them with five or more intermediate steps. Drag a copy of the entire group slightly off its former position. Send the copy back, rotate it 5 degrees, and assign the lines with black (**E**).

• Modify or further develop any of the resultant designs, or create your own design with your own specifications for a design problem (**F**).

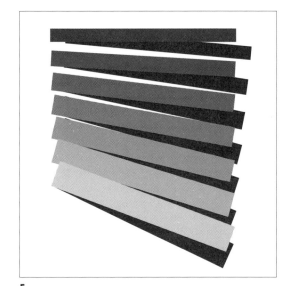

E

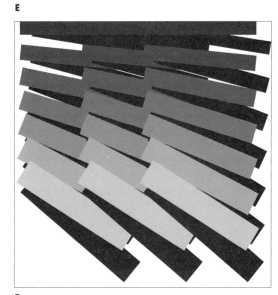

F

# 4

## POINTS AND PATHS

**4 8**

In the previous chapter we used a pen tool to click twice to obtain a straight line that has two end points. Each click actually positions an *anchor point*, and in between is a *path* that links the two anchor points.

The pen tool is probably the most essential tool in any draw program. We can use it to create not only straight lines but lines of almost any shape.

A path is defined by its anchor points. It remains invisible until it is *stroked* to give it visible weight and color/shade, whereupon it becomes recognizable as a line. However, it can also have no visual attributes and function as an edge or border to divide space.

A path does not necessarily have to be straight—it can be zigzagged, curved, or in any regular or irregular configuration, as determined by the number, nature, and location of the anchor points.

On the inspector panel or control palette, we can see the distance of a selected point from the horizontal *x-axis* as well as from the vertical *y-axis*. Markings on the edge rulers of the document window, if they are on display, can also give us such measurement values. Changing any of these values in the inspector panel or control palette can alter the position of a selected point.

We can select and move any point on a path, as well as add, delete, or change its nature to effect changes. When the two end points of the same path meet and coincide with one another, the result is an enclosed space that can be filled with color.

## CORNER POINTS

Clicking with the pen tool on a point normally designates that point as a *corner point.* Clicking the second time creates a straight path. Further clicking extends the path, which may represent an angular line with each intermediate point joined to form a protrusion inward or outward (**A**).

We can select the entire angular line and move it to a new position (**B**). We can rotate it (**C**). We can duplicate it to obtain as many copies as desired (**D**).

There is a *reflect tool* with which we can flip the line, or a copy of it, to obtain its mirror image (**E**). There is also a *skew* or *shear tool* for slanting a shape in any direction. Duplicating the slanting operation increases the slanting effect in subsequent copies (**F**).

For resizing, a *scale tool* is available for enlarging or diminishing a shape, with or without changing its proportion. Thus we can alter the size of a selected line showing a special configuration, and then repeat the transformation (**G**). We can also group the lines thus obtained, generally reduce the size (**H**), or narrow the width (**I**), and rotate a copy of the group with random changes in shades (**J**).

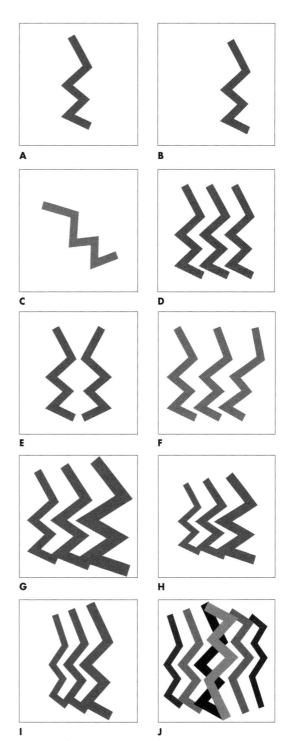

A

B

C

D

E

F

G

H

I

J

## CURVE POINTS

**50**  If we click with the *pen tool* and immediately drag
it, we can see that we actually drag out a handle
from the clicked point. Clicking and dragging the
second time, a curved path linking the first and the
second points immediately appears and a handle
emerges from the second point, as in the earlier
instance. In the dragging, we can move the mouse
to extend the handle's length or alter its direction
and observe how the curvature of the path is
affected. The points and handles are visible on
screen as long as the path remains selected (**A**).

At this stage we can continue to click and drag to
add segments to the path (**B**), or reach for a point-
er tool to move one of the points (**C**) or one han-
dle of the point (**D**) to reshape the curvature of the
path.

A point with stretching handles to define a curved
path can be either a *curve point* or a *smooth point.*
The handles determine in which direction and to
what extent the curve is to bulge. When the entire
path is deselected, all points and their handles will
be hidden from view and will not be printed. The
path becomes a curved line after it is stroked with
visual attributes (**E**).

A curved line created with curve points can be
moved (**F**), rotated (**G**), reflected (**H**), skewed (**I**),
and/or scaled (**J**) with respective tools.

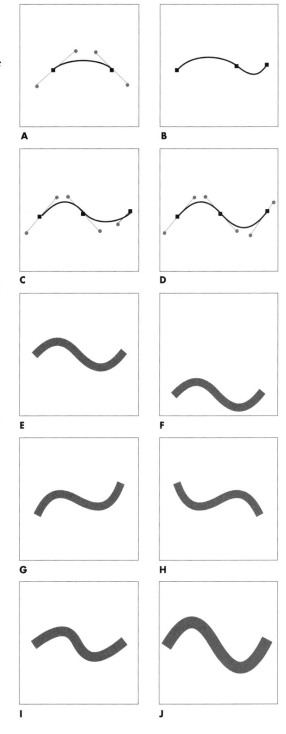

A    B

C    D

E    F

G    H

I    J

## MOVING POINTS AND SEGMENTS

To select a point on a path, first we need to click on the body of the path with the pointer tool to select the entire path and then click on the point (**A**). Some programs have a *direct-selection tool* with which we can just click on the point. After selecting the point, we can drag it to reshape the adjacent segment in any desired direction (**B**).

Selecting and dragging an intermediate point on a path (**C**) reshapes the two adjacent segments (**D**).

To reshape several adjacent segments, first we select one point and then, depressing the *shift* key, select one or more points on the same path and drag any of the selected points. All the other points remain in their locations as the selected points are moved together (**E–J**).

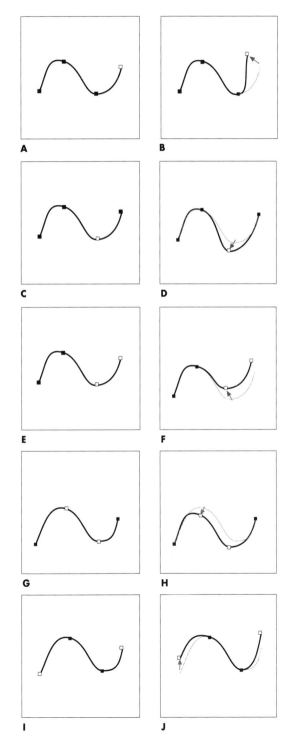

A

B

C

D

E

F

G

H

I

J

## INSERTING AND DELETING POINTS

**5 2**

Instead of moving points or handles, we can also reshape a path by inserting new points or deleting existing points. We can use the pen tool, or a special *add-point* tool, to insert a point by clicking somewhere on a selected path (**A**). The newly inserted point could be a corner or curve point.

Now we can switch to the pointer tool to move the newly inserted point, or one of the point handles, to reshape the path (**B**, **C**). We can also select an existing point on the path and move it to reshape the path, as the newly inserted point anchors the part of the path in its location (**D**).

Deleting a point simplifies the configuration of the path and possibly reshapes the path considerably. To do this, we can select a chosen point on the path and press the *delete* key. In some programs, this operation deletes a segment instead of a point. If this is the case, we need to reach for a *delete-point tool* with which we could click and remove any point on the selected path. Deletion of an end point shortens the path (**E**, **F**). Deletion of an intermediate point straightens or flattens the path (**G**, **H**).

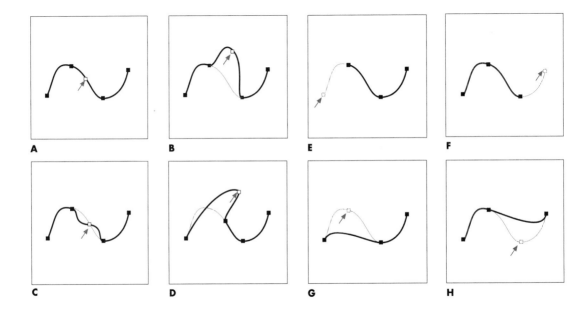

A

B

E

F

C

D

G

H

## CONVERTING POINTS

Clicking and dragging with the pen tool, we can create a path consisting of both corner and curve points (**A**). Alternatively, we can click without dragging to create a path consisting of corner points only (**B**).

Subsequently, we can reshape the path by selecting individual corner points and converting them to curve points. The angular protrusion made by the selected corner point can become a smooth curve instantly if an "automatic" option is available (**C**). We can gradually convert more corner points to curve points, if necessary (**D–G**).

We can also convert the nature of a point by choosing an option in the inspector panel or by using a special tool in the toolbox. The conversion can then be reversed; we can always change any curve point back to a corner point (**H–J**).

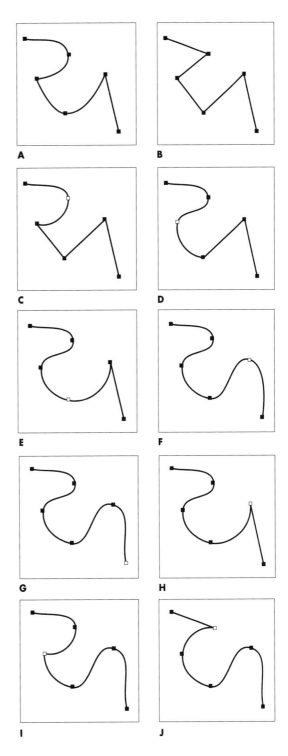

A

B

C

D

E

F

G

H

I

J

## MANIPULATING POINT HANDLES

**5 4**

As we have seen, a curve point is accompanied by two handles (**A**). The two handles lie along a straight line, so that changing one handle affects the other.

Selecting a curve point usually produces a display of its two handles. We can extend each handle in its original direction to reshape an adjacent segment (**B**, **C**). We can also move a handle and change its original direction, but this will change the direction of the other handle associated with the selected point (**D**).

If we convert a selected curve point into a corner point (**E**), we may or may not see the handles. A corner point is also accompanied by two handles that either are embedded in the point or fall along the associated path segments.

To get a handle out of a corner point, it may be necessary to depress the *option* or *alt* key before dragging with the pointer tool. Each handle should be addressed separately, and we may have to drag a second time to get the handle we want. When handles are available, we can move each handle individually to reshape adjacent segments (**F–J**).

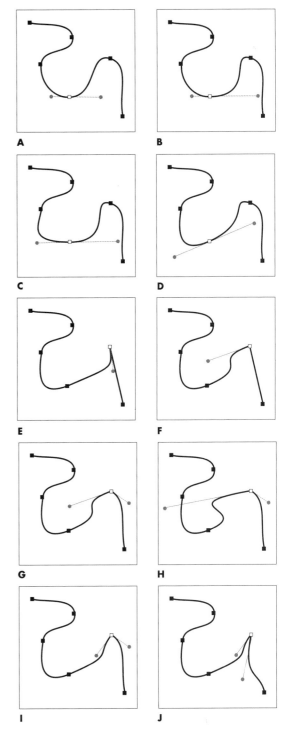

## PATHS WITH REPEATED SHAPES

It is difficult to click or drag with the pen tool to create paths composed of repeated shapes. We can, however, use the pen tool to create an initial shape that contains only corner points (**A**).

After converting some or all of the corner points to curve points (**B**), the unit is then repeated several times with respective end points coinciding. Then we engage the *join* command to create one continuous path (**C**).

Now, if desired, we can proceed to convert each intermediate corner point into a curve point to smooth out all angularity (**D**). New visual attributes can be assigned to the new shape (**E**).

The new shape can then be duplicated, with each copy in a different shade, to form a design (**F**). To accomplish more complex designs, we can experiment with more duplications and apply reflection or resizing (**G**, **H**).

**E**

**F**

**G**

**A**

**B**

**C**

**D**

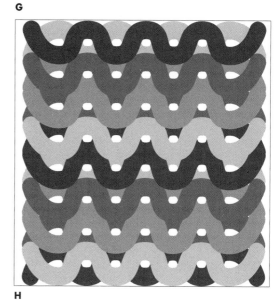

**H**

## BLENDING PATHS

**56**

Two paths of the same or different configurations, and of the same or different visual attributes, can be blended. They can have a different number of points, but must have the same type of caps and joins for the lines.

Blending two identical paths leads to repetition of the units. If they are different shades, the blend results in a gradation of shades (**A**). If there are many steps in the blend, the repeated units would seem fused together (**B**).

If the program allows, we can subselect either the commencing or the terminating path in the blend to effect instant changes to all the units. We can change its weight (**C**), its position (**D**), or its direction (**E**). We can resize it (**F**), skew it (**G**), convert points (**H**), remove intermediate points (**I**), or add a curve point after removal of points (**J**). We can duplicate the entire blend or reflect a copy of it in a composition (**K**).

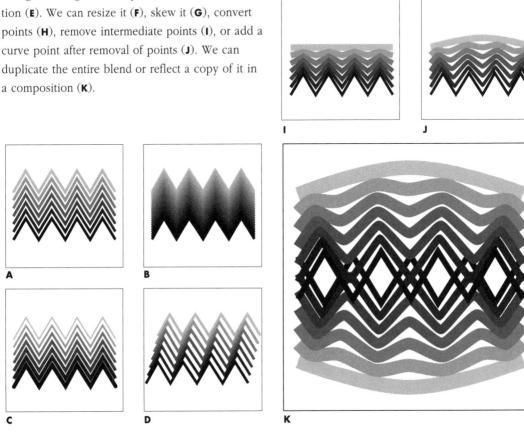

E

F

G

H

I

J

A

B

C

D

K

## CLOSING A PATH

A path that has two separate end points is called an *open path* (**A**).

To change the open path into a *closed path*, we can use the control palette or the *join* command to add a short straight path linking the end points (**B**). We can also move one end point to coincide with the other end point to close it (**C**).

A closed path can be filled with a color or gray shade (**D**). We can stroke the path in a desirable line weight and color/shade to make it visible as a surrounding edge (**E–G**). If we stroke the path in the same color/shade as the fill, the shape would seem increased in size (**H**). The heavier the line weight, the larger the shape will appear (**I**).

With the path in a prominent line weight, we can change the sharp joins into round joins (**J**).

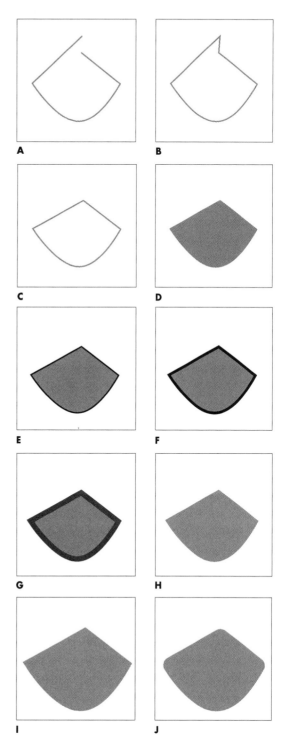

A

B

C

D

E

F

G

H

I

J

## MODIFYING CLOSED PATHS

**5 8**

A closed path forms an edge for a a planar shape. We can duplicate it, place the copy in front of the original (**A**), and perform modifications only to the copy.

Any fill is opaque. We can change the fill of the front shape to another color or shade (**B**), or to white (**C**). We can change the fill to none, allowing the back shape to show through (**D**).

Apart from applying or changing a fill, modifying a closed path is similar to modifying an open path. Any point on the path of the front shape can be moved (**E**). A handle of any selected point on the path can be dragged (**F**). A selected point can be converted from a corner point to a curve point, and vice versa (**G**). We can insert or delete points (**H**, **I**). We can skew or resize the shape (**J**).

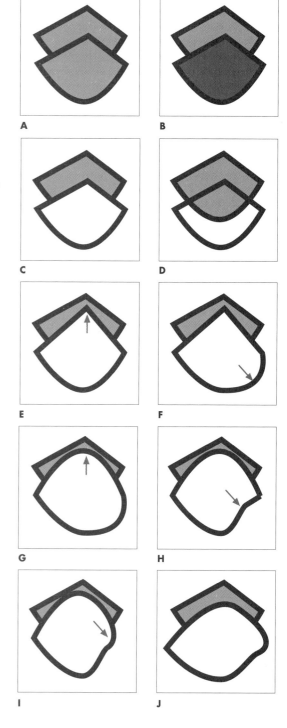

A    B

C    D

E    F

G    H

I    J

## BLENDING CLOSED PATHS

Just as we can blend open paths, we can also blend closed paths. A closed path may contain a fill and have no end points. We cannot blend a closed path that is not stroked with one that is stroked, and we cannot blend one that contains a fill with one that is not filled.

We can, however, blend a path stroked and/or filled in a color or gray shade with a path stroked and/or filled in any other color or gray shade (**A**) or even in white (**B**, **C**).

Before blending, we may have to ungroup and select a point on each closed path. Normally points at corresponding locations on each path should be chosen, so that the resultant blend does not show unusual distortion in the intermediate steps (**D**). For special effects, we can choose points at different locations (**E**).

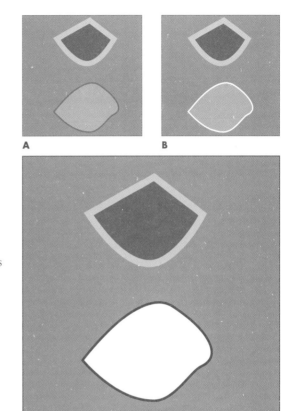

**A** **B**

**5 9**

**C**

**D**

**E**

## SUGGESTED EXERCISES

**6 0**

The aim of the following exercises is to develop proficiency with using the pen tool to create corner points, some of which may be subsequently converted into curve points and get manipulated:

- Open a new document. Choose the pen tool and click to plot eight or more corner points to form a horizontal zigzagged path. Assign this path a line weight of no less than 4 points, round caps and round joins, and a shade of 60% black (**A**). Repeat the path five or more times equidistantly. Change alternative paths to a different shade. Group all the paths. Resize it appropriately (**B**). Reflect a copy of it 90 degrees horizontally across (**C**). Save the document as **Exercise 2.1**.

- Resave the document as **Exercise 2.2**. Ungroup the units. Move individual paths to new locations in a free arrangement. Rotate, skew, or resize some paths and change their visual attributes. Save the document again (**D**).

- Resave the document as **Exercise 2.3**. Delete all paths except one. Reflect a copy of this path 180 degrees vertically down. Assign the paths different line weights and shades. Blend the two paths in twelve steps so that they are clearly distinguishable. Reflect a copy horizontally across and resize the composition appropriately (**E**).

**A**

**B**

**C**

**D**

**E**

**F**

**G**

- Open a new document and use the pen tool to click an L-shape path. Drag four or more copies from this so that they are in a vertical, equidistant arrangement. Join the finishing end point of one to the beginning end point of another in a sequence to form a new path. Rotate a copy of this new path 180 degrees and reposition the copy sideways. Assign each path different gray shades and blend them in six or more steps. Scale the resultant blend as a group to narrow its width. Repeat the group two or more times across. Save the document as **Exercise 2.4** (**F**).

- Resave the document as **Exercise 2.5**. Delete all elements except one pair of commencing and terminating paths. Rotate the paths to a horizontal position, generally reduce their height, and change the intermediate corner points of the terminating path. Blend them in six or more steps (**G**). Copy the commencing and terminating paths of this blend. Arrange the terminating path in a higher position than the commencing path, so that the commencing and the terminating paths are reversed. Blend them in six or more steps. Move this later blend directly below the earlier blend and save the document (**H**).

- Resave the document as **Exercise 2.6**. Select and group all elements; clone a copy directly in front. Stroke this copy in white and in a line weight of about 2 points (**I**). Group everything and drag a copy of the new group vertically below to extend the composition. Save the document (**J**).

**6 2**

F

I

G

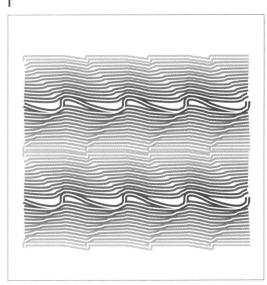

J

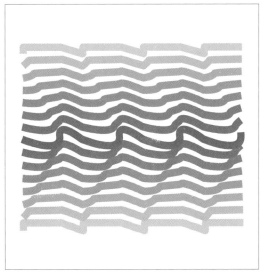

H

**5** PLANAR SHAPES

**6 4**

In the preceding chapter we used a pen tool to create closed paths that form planar shapes. Actually, there are a number of shape tools with which we can create planar shapes of regular, geometric configurations.

All draw programs provide a *rectangle tool* for drawing rectangles and squares, and an *ellipse tool* for drawing ellipses and circles. Some may also provide a *rounded-rectangle tool* for drawing square or rectangular shapes with round corners.

Furthermore, a *polygon tool* may be available for drawing regular polygons and star shapes instantly, in any number of sides or points.

For irregular planar shapes, a *freehand tool* is often available for creating paths to enclose space, and a *brush tool* for drawing bold lines that are actually elongated planes.

Shapes thus obtained can always be manipulated. Two or more shapes that overlap can merge with, or crop, one another to form an entirely new shape.

## RECTANGLES AND SQUARES

With the mouse cursor representing the rectangle tool, we can drag diagonally across the screen, starting from one upper corner and moving to the opposite lower corner, to make a rectangle with two identical vertical sides, two identical horizontal sides, and four right angles (**A**).

This rectangle can be so narrow and elongated that it approaches the configuration of a line (**B**), or have all sides equal constituting a square (**C**). To attain a perfect square, we can depress the *shift* key as we drag with the tool cursor.

The rectangle or square often comes as a grouped shape. It is a closed path with four corner points forming vertical and horizontal segments, and contains no fill.

We can draw the rectangle or square from a center if we depress the *option* or *alt* key. Some programs may show a central point of the shape, in addition to the corner points (**D**).

Positions and dimensions in numerical values can be accessed in the inspector panel or control palette. Altering any of the numbers there effects instant changes. As the rectangle remains selected, we can stroke and fill the path in various ways before we decide on the proper visual attributes (**E–J**).

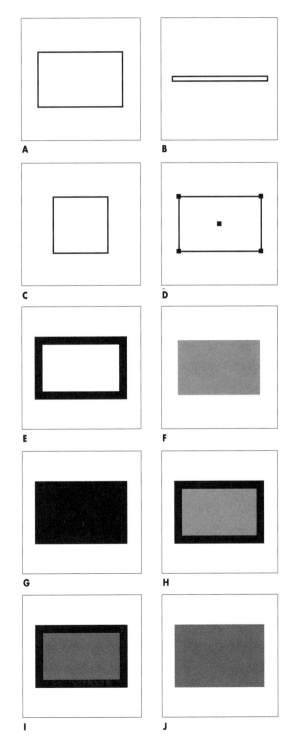

A

B

C

D

E

F

G

H

I

J

## ROUNDED RECTANGLES OR SQUARES

**6 6**

To create rounded corners for a rectangle or square, we can use a control palette to enter a numerical value for the radius (**A**, **B**).

Rounding the corners with a high numerical value changes the configuration toward an elliptical shape (**C**, **D**).

Actually, a rounded rectangle or square has eight corner points (**E**). The curved lines at the corners are caused by handles projecting slightly from the points. Moving these handles changes the curvature of the short segment forming the corner (**F**, **G**).

We can modify more than one corner of the rectangle (**H**), subsequently stroke and fill it (**I**), and then resize it with a change in proportion (**J**).

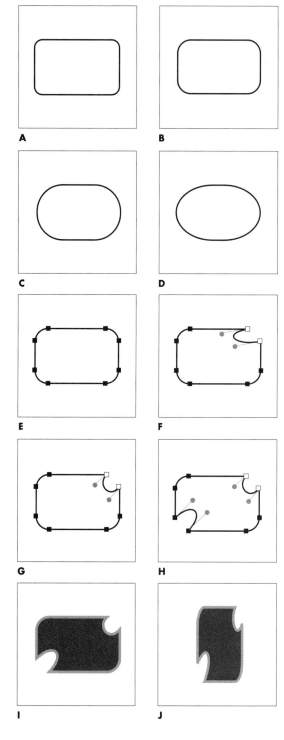

## ELLIPSES AND CIRCLES

Drawing an ellipse was once a difficult task. Now we can create a perfect ellipse with one single mouse movement. Dragging the tool cursor diagonally creates an ellipse from a center (**A**), and dragging while holding down the *shift* key creates a perfect circle (**B**). If we depress the *option* or *alt* key while dragging, the shape forms from a center (**C**).

The shape, as it remains selected, may show four black square dots at four corners representing the object handles that we can move with the pointer tool to change the shape's size and proportion (**D**). In this case, the shape can be ungrouped to show four points on the path: at top, bottom, left, and right (**E**). They are curve points with outstretching handles (**F**).

The circle is the only shape that displays no visible change with rotation. The ellipse, with its differing height and width, can have different orientations (**G**, **H**). Rotating or reflecting the ellipse leads to similar results (**I**). Skewing can change its size and proportion but cannot distort it (**J**).

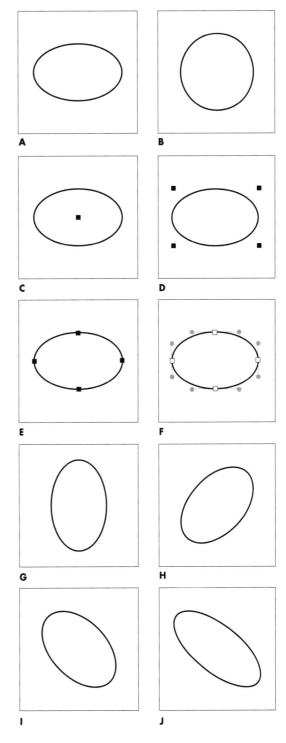

A          B

C          D

E          F

G          H

I          J

## TRIANGLES AND POLYGONS

**6 8**

Regular polygons have sides of the same length, forming the same angle at joins. With a polygon tool we can draw polygons with as few sides as three, which makes an equilateral triangle (**A**), to as many sides as twenty, which approaches a circle (**B–I**). The shape's orientation can be adjusted by dragging diagonally with the polygon tool.

Triangles and polygons thus created contain corner points. They are closed paths that are not initially grouped. We can group each path as soon as it is created, as this may help in rotation, skewing, or resizing (**J–M**).

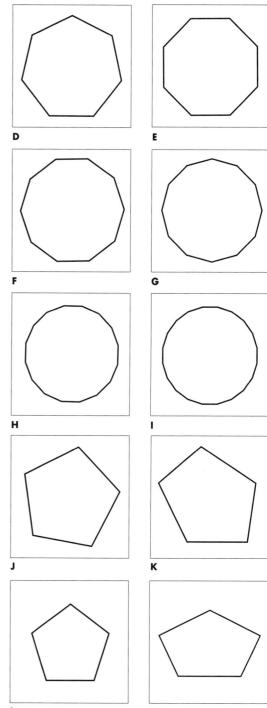

D

E

F

G

H

I

A

B

J

K

C

L

M

## STAR SHAPES

Bending the middle point of each side in a triangle or polygon creates a star shape. The same polygon tool provides an option for drawing a star shape. Some programs may have a separate tool for this.

As with creating polygons, we can create star shapes that have three to twenty points. We can also create more acute or obtuse angles in the tips or bends (**A–N**). We can rotate (**O**), skew (**P**), or resize the shapes in various ways.

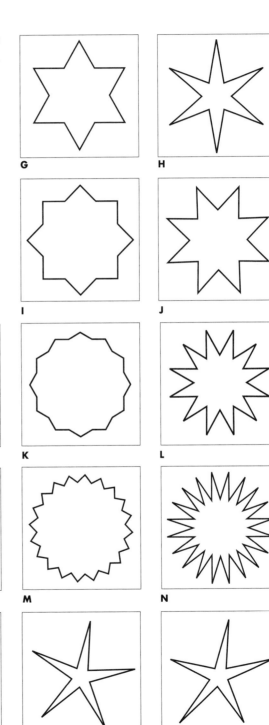

G

H

I

J

A

B

K

L

C

D

M

N

E

F

O

P

## MODIFYING A GEOMETRIC SHAPE

**70**

Shapes obtained with the rectangle tool, the ellipse tool, and the polygon tool are geometric shapes that are symmetrical in one or more directions. We can modify such shapes without changing them into irregular shapes.

For an ungrouped circle, we can select the top point and use an arrow tool to move it, pixel by pixel, to change the curve along the upper edge of the shape (**A**, **B**). Subsequently we can convert the curve point into a corner point and move each associated handle higher to pull each adjacent curve separately, effecting a sharp indentation where the point lies (**C**). To ensure that both handles are moved in the same distance and in a corresponding direction, we can use a horizontal guide dragged from the edge ruler for reference.

In a similar way we can convert the bottom point into a corner point and move the associated handles upward to make a sharp protrusion at the point (**D**).

For an ungrouped square, we can rotate it 45 degrees and move two side points slightly to narrow down the overall width of the shape so that it becomes a rhomboidal shape (**E**). Then we can select each side point, which remains a corner point, and draw a handle out horizontally to curl a pair of opposite segments (**F**). Afterwards we can change the top and bottom corner points to curve points (**G**). Moving handles from the two side points affects the top-right and bottom-left curves and sharpens the protrusion of those side points (**H**).

With the polygon tool creating an eight-pointed star (**I**), we can convert all projecting corner points to curve points (**J**).

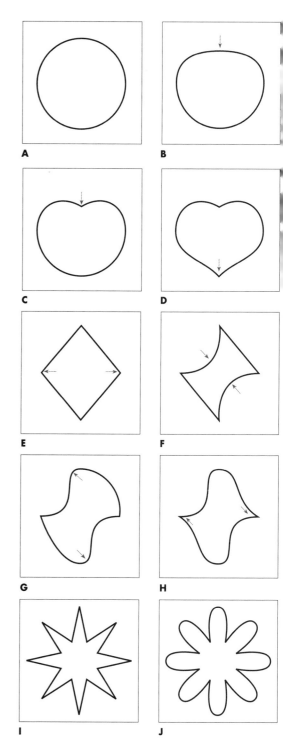

## FREEHAND SHAPES

We can use the freehand tool that is available in the toolbox and draw a path to enclose space, resulting in a closed path when the end points are properly joined (**A**).

The shape normally has imperfections. To reshape it, we can drag a handle of one curve point (**B**), move some points (**C**), add a point somewhere and move it (**D**), and convert a point somewhere (**E**). Then we can reflect the resultant shape and stroke and fill it after resizing (**F**).

## CALLIGRAPHIC SHAPES

Using the freehand tool, we can predetermine a line weight of 15 points or more, with round caps and joins, to create the kind of calligraphic shapes attained with a brush (**A**). We can always switch to *keyline* or *artwork* mode to view the shape as a thin line. (**B**). The shape can be edited by moving the points on the path. On the 15-point black line, we can use 2-point or 4-point black lines to add, or white lines to subtract, small areas on the line body (**C**). The edited shape is actually formed with numerous long and short lines (**D**).

We can now reach for the *trace tool* in the toolbox and drag a selection area around the resultant shape. The operation instantaneously creates an outlined shape (**E**) that can be stroked and filled as the former shape is discarded (**F**).

If we draw a shape with a 15-point black line (**G**), then refine it with finer black and white lines (**H**), tracing it produces two separate outlines, with one representing the hole in the loop (**I**). We need to select both outlines and use a *join* command to create one *composite*, which can then be stroked and filled to show the hole in the loop (**J**).

The freehand tool may have a function to draw lines resembling what can be achieved with a calligraphic pen (**K**). Each shape created comes outlined (**L**). We can stroke the outline in black with a heavier line weight, with round caps and joins, fill it black (**M**), and trace the resultant shape with the trace tool. The new outline obtained with the trace tool is then stroked and filled as desired, with the former shape discarded (**N**). Some programs provide a separate brush tool with round and flat tips for directly achieving these effects.

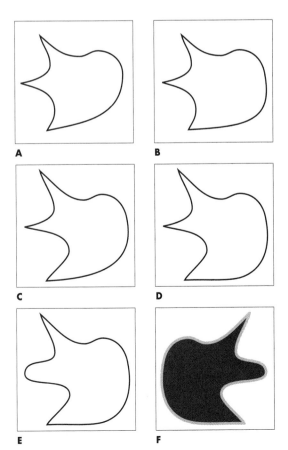

**A**

**B**

**C**

**D**

**E**

**F**

**7 2**

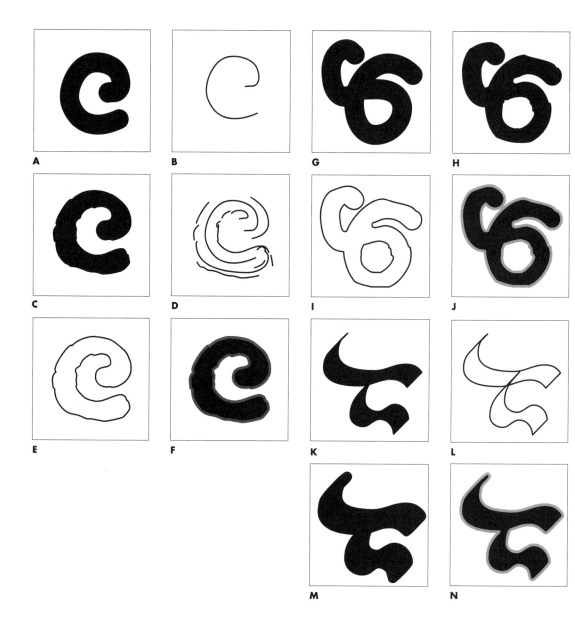

A

B

G

H

C

D

I

J

E

F

K

L

M

N

## COMBINING SHAPES

When there are two or more shapes in different configurations and overlapping visual attributes (**A**), we can combine them into one single shape by using the *unite* or *union* command. In this way, the former shapes have the same visual attributes (**B**) and are bound with one continuous path enclosing an uninterrupted area.

There are other options for combining shapes. Using the same shapes, we can engage the *punch* command so that the topmost shape effects a negative action similar to punching a hole there (**C**). We can also use the same shapes and reach for the *transparency* command to get an illusion of transparent planes stacked together (**D**). This illusion is best achieved when all paths are stroke-free (**E**).

If we draw an additional shape, such as a square, directly on top of the new shape (**F**), we can trim away everything outside the additional shape by effecting the *crop* command (**G**). If we clone this additional shape before cropping, and fill the copy in a shade and send it to the back, we can have the cropped shape combined with a background shape (**H**).

We can add a further shape on top of this new shape (**I**) and use the transparency command to achieve more transparent layers (**J**).

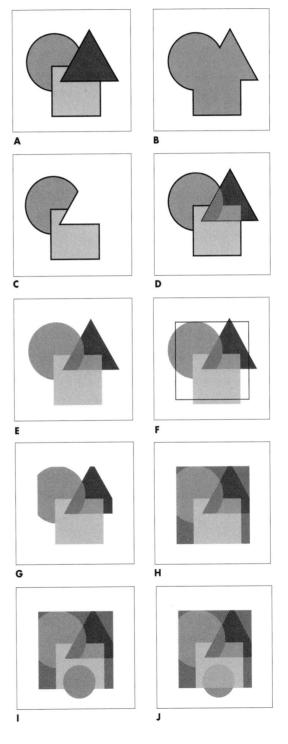

A

B

C

D

E

F

G

H

I

J

## BLENDING SHAPES

**7 4**

In the last chapter we demonstrated blending closed paths. Actually, we can blend several shapes in a sequence. Some programs may facilitate blending more than two shapes in one operation. If this is not allowable, we can blend two shapes at a time, clone a terminating shape for use as a commencing shape, and start the next blend.

Blending shapes of different configurations and visual attributes shows each shape marking an intermediate change (**A**). We can see the edges of every shape if the paths are not filled but only stroked (**B**). We can fill shapes with different shades to attain greater clarity (**C**). We can overlap the filled blend with an unfilled blend (**D**). The two coinciding blends can be separately manipulated to achieve desired effects (**E**, **F**).

We can group coinciding blends and duplicate and rotate a copy to attain a composition (**G**).

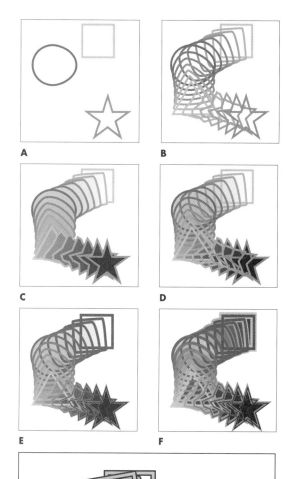

A            B

C            D

E            F

G

## JOINING SHAPES

When discussing calligraphic shapes earlier in this chapter, we joined separated shapes with a *join* command to get traced results showing a hole in a loop. Now we can explore further effects by joining closed paths.

Starting with three shapes of different visual attributes (**A**), we can engage the *join* command to connect them. They will be changed to display the same visual attributes, which show as hollow areas at overlappings (**B**). The overlappings are filled with the same shade as other filled areas if an "even/odd fill" option is not checked (**C**). Joining does not unite the shapes into one; each can be subselected, moved (**D**), and manipulated (**E**).

We can stroke and fill the joined shape with new visual attributes (**F**), clone a copy on top, and stroke and fill the copy differently after moving it to a slightly off-position (**G**). The two composites can be joined again to achieve wide, open hollow spaces (**H**). The resultant shape can than be duplicated and altered with new fills and strokes (**I**, **J**).

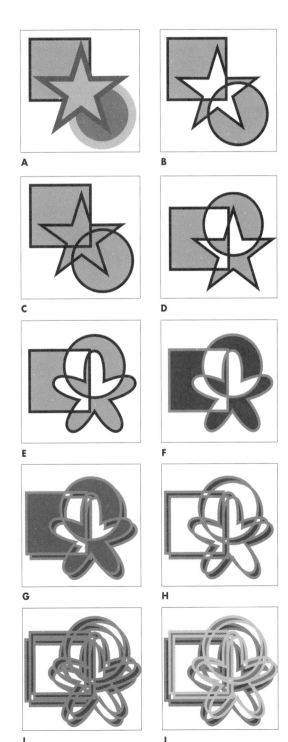

A

B

C

D

E

F

G

H

I

J

## DISTORTING AND DIVIDING SHAPES

**76**

Any shape can be distorted. Distortion introduces irregularity to a regular shape and probably also adds complexity. If we start with a circle that is both stroked and filled (**A**), we can ungroup it and move handles of one or more points to alter the curvature of some segments (**B**).

To achieve an overall distortion of a shape, we can reach for a *distort* command or a *distort* filter, which may be associated with a dialog box showing the shape's outline in a box-like envelope with handles that can be pushed and pulled to accomplish transformation (**C**). The relatively smooth outline of the shape can be roughened (**D**) or zigzagged (**E**).

There is often a *knife* or *scissor* tool in the toolbox that allows us to draw a freehand or straight line, one or more times, on top of a selected shape. The tool's operation divides the shape into parts, and any part can be selected and moved or rotated, thus revealing the gap or gaps (**F–H**).

A divided shape can be generally distorted (**I**), or or we can roughen the edges of the various parts (**J**). The divided shape can be ungrouped so that we can stroke and fill the separated elements differently (**K**, **L**).

**C**

**D**

**E**

**F**

**G**

**H**

**I**

**J**

**A**

**B**

**K**

**L**

## SUGGESTED EXERCISES

Planar shapes are fundamental elements in visual design. They are closed paths that can be both stroked and filled. There are more tools in a draw program for creating planar shapes than for any other elements. There are also more ways, in the form of commands or filters, for manipulating them. The following exercises aim to develop understanding and skill in using such shapes:

**A**

**B**

- Open a new document. Use one of the shape tools and draw a small unit that is repeated several times so that units overlap one another (**A**). After stroking and filling the units, unite them into one shape (**B**). Clone a copy of the shape and reflect it horizontally. Group both the original shape and the reflected copy. Drag a copy of the group slightly off-position. Ungroup all elements. While the elements remain selected, join them into one single composite (**C**), save the document, and name it **Exercise 5.1**.

**C**

- Resave the document as **Exercise 5.2**. Draw a circle to overlap the composite. Send this circle to the back and select all elements and use the *punch* command to impose hollow areas on the solidly filled circle. Reassign visual attributes to the resultant shape and save the document (**D**).

**D**

**7 8**

- Resave the document as **Exercise 5.3**. Clone a copy and place it on top of the original. Select the copy and assign new visual attributes to it (**E**). Use the knife tool and perform several straight cuts diagonally across the copy while the copy remains selected (**F**). Subselect some elements at random after the cut and move them slightly off-position to reveal partially the shape at the back (**G**). Save the document.

- Resave the document as **Exercise 5.4**. Delete all elements except one that is a closed path in an interesting shape. Drag a copy of this shape and rotate it, assigning new visual attributes to it. Blend the two shapes in a desired number of steps and save the document (**H**).

E

F

G

H

6

COLORS AND GRADIENTS

**80**

In the previous chapter closed paths forming planar shapes were stroked and/or filled with gray shades. They can also be stroked and/or filled with color, if desired. Color adds a special dimension in visual communication, with emotional implications and symbolic associations.

We shall examine the basic properties of color and ways of creating, mixing, and changing colors. We shall also explore how to establish color schemes and demonstrate interaction of color leading to unexpected visual results.

Blending lines in color can produce a range of gradually changing colors. Closely spaced elements in a blend can resemble a color gradient. There is a gradient option, however, available in any draw program, for filling closed paths. We can have any color or gray shade smoothly blending with any other color or gray shade, and even further colors or gray shades in a sequence.

What was once a painstaking process in painting and drawing with the hand is now a simple operation. With improved computer speed and performance, the use of a gradient has gained increasing popularity.

## NAMING COLORS

We perceive color through our eyes and would identify them with appropriate names in our mother tongue. These common color names have formed an integral part of our daily language for many centuries. They existed long before any theories of color are discovered.

Such color names in most cultures commonly include red, orange, yellow, green, blue, and purple, describing colors that might vary considerably among people of different times and places (**A**). Even people from the same culture can disagree widely on what is a standard red or blue, for instance (**B**, **C**).

## COLORED LIGHTS

Scientific advancement has discovered that perception of color is produced by the passage of colored lights through our eyes, which is then interpreted by the brain. Light is a kind of electromagnetic energy in the form of waves that can be measured in terms of *wavelengths*.

Experiments have shown that sunlight passed through a triangular glass prism produces a band of colors constituting the *spectrum*, ranging from red (representing the longest wavelength) to violet (representing the shortest visible wavelength) (**D**).

Various theories of color have been proposed, based on the phenomenon of colored lights. It is now well accepted that three primary colors, as colored lights, named *red, green,* and *blue* by scientists, can be intermixed to form all colors in the spectrum (**E**). Combining any two primary colors produces *secondary colors*, and combining all three produces white, which results from the full presence of light (**F**). Black results from the total absence of light.

It must be pointed out that although the terms red, green, and blue have been used to name the three primary colors, the colored light red is close to an orange-red, and the colored light blue is really a purplish blue, as perceived by most people.

Sensation of colored lights now forms an essential part of our daily living as we watch television and use computers that display full color images on screen.

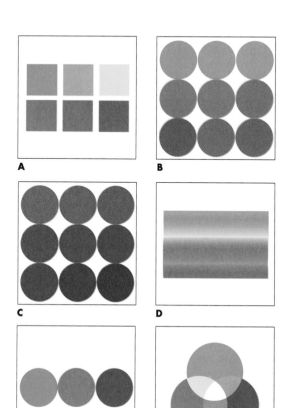

A

B

C

D

E

F

## PIGMENTS

**82**   Our sensation of color comes less from direct con-
tact with colored lights than from seeing objects,
materials, and scenery in our environment. Many
man-made objects may have been covered with a
coat of paint, fibrous materials may have been
dyed, and publications have been printed with
inks.

**A**

In contrast to colored light, the variety of colors in
paints, dyes, and inks is the effect of *pigments* that
have been extracted from plants or minerals or
synthetically produced and incorporated in the
manufacture of the product.

Pigments contained in commercial, industrial, or
artist's materials can cover or penetrate surfaces.
When light falls on a surface treated with pigment,
the light is partially absorbed and also partially
reflected. Only specific wavelengths of the light
reach our eyes, and are interpreted by our brain as
color sensation.

Most of us have had experience with mixing differ-
ent paints to produce a range of colors and apply-
ing paint to a surface. Pigments are available in
three basic colors from which most other colors
can be mixed. These are generally identified as
red, yellow, and blue (**A**); mixing any two of them
produces orange, green, and purple (**B**).

**B**

Red and blue as pigments are not the same as the
primary colors red and blue as colored lights (**C**).
This can lead to some confusion when we describe
and communicate about colors in our daily lan-
guage.

**C**

## ADDITIVE AND SUBTRACTIVE MIXING

Mixing colored lights is referred to as *additive color mixing*, because there is more light and brighter effects.

Mixing pigments is referred to as *subtractive color mixing*, because the particles forming the pigmented surface tend to absorb more light or produce greater interference to reflecting light, resulting in a lowering of brightness and vibrancy.

Nature does not provide standardized pigments in red, yellow, and blue with which we can mix all other colors. We have pigments in a range of different reds, different blues, different greens, different yellows, etc., and we can only choose what comes closest to our needs for color mixing.

## COLOR INKS IN PRINTING

Commercial printing today has successfully proven that three standard process inks—cyan, magenta and yellow (**A**)—can produce practically all the colors in the spectrum. These could be regarded as the true primary colors of pigments. These colors, printed on a white surface, act as filters through which white light is reflected. Solid colors become tints as they break down into small dots as halftones that allow more reflected light to get transmitted (**B**).

Superimposing cyan and magenta produces blue, magenta and yellow produces red, and yellow and cyan produces green (**C**). The colors thus obtained come very close to the primary colored lights. Theoretically, when cyan, magenta, and yellow all overlap, all reflected light from the white surface can be completely blocked, resulting in black (**D**). This black, however, is often not dark enough to be recognized as black. Therefore, to achieve the darkest black, as well as to enhance tonal contrast in printing, a separate black ink is added as a fourth color. Printing becomes a four-color process (**E**).

The same color concept is adopted in computer outputs. Desktop inkjet printers linked to computers generally have cyan, magenta, yellow, and black as the four basic inks. The more advanced printers may have additional inks for improving color vividness.

A

B

C

D

E

## THE BASIC COLORS

The four process inks—cyan, magenta, yellow, and black—along with the three primary colored lights and white, make up the eight basic colors.

These colors are frequently identified by their abbreviated names: **C** is for cyan, **M** is for magenta, **Y** is for yellow, **K** is for black, **R** is for red, **G** is for green, **B** is for blue, and **W** is for white (**A**). The abbreviated names are standardly used in both color science and the printing industry.

As it has been demonstrated, when colored lights are used, combining **R** and **G** creates **Y**, **G** and **B** creates **C**, **B** and **R** creates **M**, and **R**, **G,** and **B** together creates **W**. When color pigments are used, mixing **C** and **M** creates **B**, **M** and **Y** creates **R**, **Y** and **C** creates **G**, and **C**, **M** and **Y** together creates an approximate shade of **K**. The six chromatic colors **R**, **Y**, **G**, **C**, **B** and **M** can be linked to form a color wheel (**B**). Varying the percentages of **K**, or intermixing **W** and **K**, forms a range of gray shades (**C**).

## STROKING A PATH

Any open or closed path can be stroked with color in any line weight to distinguish it from the white background (**D**, **E**).

The background can also be filled with a different color. Colors of the path and the background can be closely related or widely different (**F**, **G**).

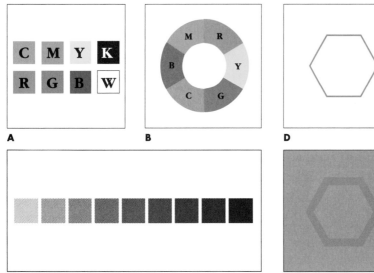

**A**

**B**

**D**

**E**

**C**

**F**

**G**

## FILLING A PATH

A closed path stroked with color can be filled with color that is different from the background color. The composition then contains three colors (**A**). The fill can be in white (**B**), black (**C**), or in the same color as the stroke (**D**). In the latter case, the stroke is no longer noticeable and the shape appears to be larger.

To hide the stroke, we can change the stroke of the path to "none," an option that allows the color of the fill to come in direct contact with the background color (**E–H**). Different color grounds provide different effects.

The filled shape can be placed on a black or white background (**I**, **J**). In most cases, a white background is similar to a background that is not filled.

A

B

C

D

E

F

G

H

I

J

## CREATING COLORS

Most programs provide a color mixer palette with which we can create colors for stroking and filling. The palette is usually in the form of four sliders, representing the four process inks: cyan (**C**), magenta (**M**), yellow (**Y**), and black (**K**). Moving the sliders simulates physical mixing of each ink color in a certain percentage to create a desired color.

To get an orange color, for instance, we would need 0% **C,** 50% **M,** 100% **Y**, and 0% **K** to constitute the mixture (**A**). The color would change to brown with addition of 20% **K** to the other ink colors (**B**).

Every color has three properties: *hue, lightness,* and *saturation.* To create a color, we should first have some notion of its hue, which generally refers to how color is described, classified, or named in our daily language. Then we should determine its lightness, meaning its relative brightness or darkness, and its saturation, meaning its relative brilliance or dullness.

## HUE OF A COLOR

*Hue* generally refers to the way a color is described in our daily language. We identify a color as red, red-orange, or red red-orange, though this is rather imprecise.

Technically speaking, *hue* refers to the relative position of a color along the spectrum from red to violet (**C**). (Beyond the visible spectrum are infrared and ultraviolet rays that cannot be seen by the human eye.)

Selecting a color usually starts with choosing which hue is to be used, before considering the lightness and saturation of the color. In choosing a hue, we should also consider how it is related to adjacent hues in the spectrum. For example, a green color could be yellowish green or bluish green. The accompanying diagram shows an arrangement of hues in gradual transitions from one row to the next (**D**).

**A**

**B**

**C**

**D**

## LIGHTNESS OF A COLOR

A pure color can be naturally bright or dark. Yellow is the lightest and purple is the darkest. We can compare the commonly seen pure colors to individual grays in a gray scale made with different percentages of black (**A**).

Variations in lightness of a color can be accomplished by mixing with white to increase and with black to decrease its original brightness. Yellow and orange, being naturally bright, require very few steps of mixing with white but many steps of mixing with black. Blue and purple colors require many more steps of mixing with white to achieve numerous tints, and fewer steps of mixing with black (**B**).

To judge the lightness of a color, we can switch the color display of our monitor from thousands or millions of colors to 256 grays. The effect is only approximate and varies with equipment.

**A**

**B**

## SATURATION OF A COLOR

**8 8**

Pure colors are fully saturated. To attain saturation, we can mix only two of the three process ink colors (cyan, magenta, and yellow) in the color mixer palette, and have one or both of the colors in the 100% strength. There should not be any black in the mixture.

To see a range of colors from ultimate brilliance to achromaticity in a specific hue, we can blend a fully saturated hue with a gray shade that represents its relative lightness (**A**).

We can also blend two contrasting saturated hues to obtain a range of colors with both hue and saturation changes in the mixture. The resultant color in the middle of the blend would be the least saturated (**B**).

A composition consisting of all saturated colors displays vibrancy (**C**). We can also desaturate some colors to enhance the intensity of the remaining saturated colors (**D**).

**A**

**B**

**C**

**D**

## ADJUSTING COLOR PROPERTIES

The program may provide a panel, filter or command for separately adjusting the three properties of color. If this feature cannot be found, we can use the color mixer palette to create replacement colors.

**A**

The stroke or fill of a color can be seen in a box on the inspector panel. This color can be dragged with the pointer tool to the mixing well of the color mixer palette so that we can identify the percentage of cyan, magenta, yellow, and/or black as component colors. With the information, we can move sliders of each component color or enter numerical percentage values to effect adjustment.

**B**

Starting with a composition in full color (**A**), we can adjust any hue by increasing or decreasing the content of one or more of the component colors: the hue might appear warmer with addition or increase of magenta and/or yellow, and cooler with addition or increase of cyan (**B**).

**C**

Lightening a color is accomplished by decreasing the percentage of one or more component colors (**C**). Darkening a color requires introduction of more black (**D**).

**D**

A saturated color is created by giving full strength to colors. To desaturate a color, we can decrease the content of each component color and probably also add some black. Alternatively, we can add to the mixture the component color that is absent or has the lowest content. Desaturating most of the colors in a composition makes it quieter and more mysterious in feeling if contrast in lightness is considerably minimized (**E**).

**E**

## INTERACTION OF COLORS

Color interaction takes place when two or more colors overlap or are adjacent. The same color often looks different with different backgrounds or with colors that are in direct contact with it.

A color usually appears brighter on a darker background, and darker on a brighter background (**A**). It can seem cooler on a warmer background, and warmer on a cooler background (**B**).

A moderately saturated color can gain brilliance on a background of desaturated color, and it can look dull on a background of fully saturated color (**C**).

A gray shade can suggest a faint warm color when placed on a fully saturated cool color background. It changes to a faint cool color when the background shows a fully saturated warm color (**D**).

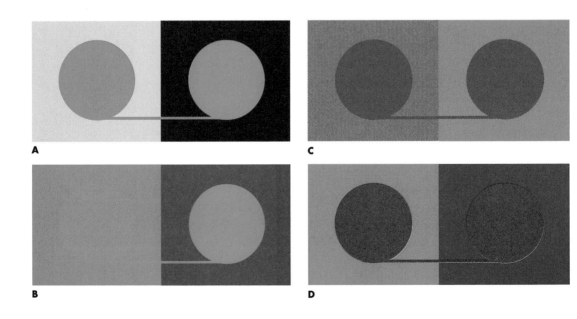

**A**

**C**

**B**

**D**

## GRADIENTS

Instead of a flat color or gray shade, we can fill a closed path with a *gradient*. A gradient is a range of colors or grays in subtle gradation. This can be a linear progression or a radial progression.

A gradient in linear progression is like a group of closely spaced or overlapped straight lines in a parallel and equidistant arrangement (**A**). We can begin a gradient in any color or gray shade and end it in any other color or gray shade (**B–F**).

A gradient in a radial progression is like a series of closely spaced concentric circles with a definite center (**G**). We can have any color or gray shade beginning in the center and any other color or gray shade ending at the bordering edges (**H–J**).

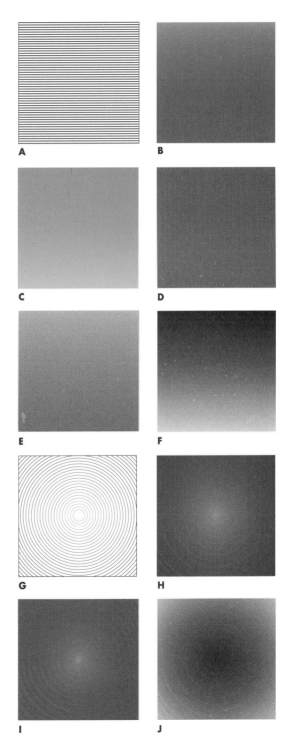

A

B

C

D

E

F

G

H

I

J

## MODIFYING GRADIENTS

Some programs allow creation of multicolored gradients. We can add one or more intermediate colors or gray shades to linear and radial gradients between the beginning and ending colors (**A–D**). We can also have a longer passage of one particular color or gray shade at any position by dragging a color indicator on the palette and treating it as an extra intermediate color to add to the gradient formation (**E**, **F**).

A linear gradient can be rotated to any desired angle inside the filled shape (**G**, **H**). A radial gradient can have the center shifted to any desired position (**I**, **J**).

The background for a gradient-filled shape can also be filled with a gradient, which can be similar to or different from the shape itself (**K–N**).

E

F

G

H

I

J

A

B

C

D

K

L

M

N

## COMPOSING WITH GRADIENTS

A closed path or shape filled with a gradient (**A**) can be rotated in any direction, with the gradient following the rotation (**B**). Similarly, we can scale, reflect, and/or skew the shape with the gradient correspondingly transformed (**C**, **D**).

The transformed gradient-filled shape can be repeated to form a pattern (**E**), which can be cropped by another shape that is also gradient-filled (**F**). A composition can be accomplished by transforming and duplicating this shape on a background containing a different gradient fill (**G**).

A

B

C

D

E

F

G

## COLOR SCHEMES

**94**

Colors used in stroking the path and as flat or gradient fills inside the shapes and on the background constitute color schemes.

Color schemes fall into four basic categories: analogous, contrasting, of low saturation, and of matching lightness.

For an *analogous color scheme*, we use a range of hues that are closely related in the spectrum. The colors representing the hues may have slight variations in lightness and saturation, and they may be from the same color family. The effect expresses a kind of soothing harmony (**A**, **B**).

A *contrasting color scheme* comprises two or three groups of colors that interact strongly with one another. Each group consists of analogous hues that may have slight variations of lightness and saturation. This kind of color scheme conveys vivacity (**C**, **D**).

The analogous and the contrasting color schemes usually feature colors in relatively high saturation. We can have a *low-saturation color scheme* that features mainly muted colors, suggesting a feeling of maturity and sophistication (**E**, **F**).

Using a *color scheme of matching lightness*, we can use colors that conform, more or less, to the same degree of lightness. The colors could be generally bright, dark, or moderate in tone, with juxtaposed high and low saturations. A color scheme in the bright tone might convey light-heartedness or femininity, in the dark tone distress and moodiness, and in the moderate tone contemplative thoughtfulness (**G–J**).

A

B

C

D

E

F

G

H

I

J

## SUGGESTED EXERCISES

Use one or more shape tools to draw regular geo-
metric shapes of various sizes to form a composi-
tion. Some shapes can go beyond the border of the
frame of reference (**A**). What lies outside the bor-
der can be cropped. To do this, after selecting all
the shapes except the frame, use the *cut* command
to remove them, and then paste them back inside
the frame by using the *paste-inside* command (**B**).
Some programs may have a different procedure for
this operation.

**A**          **B**

Once the shapes are pasted inside the frame, they
cannot be changed. To fill or modify the shapes,
use the *cut-contents* command to release them and
place them in front of the frame of reference. Do
not stroke the shapes and the frame after filling
them. Always save the document after each com-
pletion.

- Fill the shapes and the background in rela-
  tively cool hues in the blue and purple range
  to attain an analogous color scheme. Save
  the document as **Exercise 6.1** (**C**).

**C**

- Resave the document as **Exercise 6.2**. Fill
  the shapes and the background in distinctly
  different colors to achieve a contrasting color
  scheme (**D**).

- Resave the document as **Exercise 6.3**. Fill
  the shapes and the background in muted
  colors to achieve a low-saturation color
  scheme (**E**).

- Resave the document as **Exercise 6.4**. Fill
  the shapes and the background with relative-
  ly bright colors to achieve a color scheme of
  matching lightness (**F**).

**D**

**96**

- Resave the document as **Exercise 6.5**. Change all flat fills to gradients, featuring generally warm colors to establish an analogous color scheme (**G**).

- Resave the document as **Exercise 6.6**. Fill the shapes and the background with linear and radial gradients, using muted colors to establish a low-saturation color scheme (**H**).

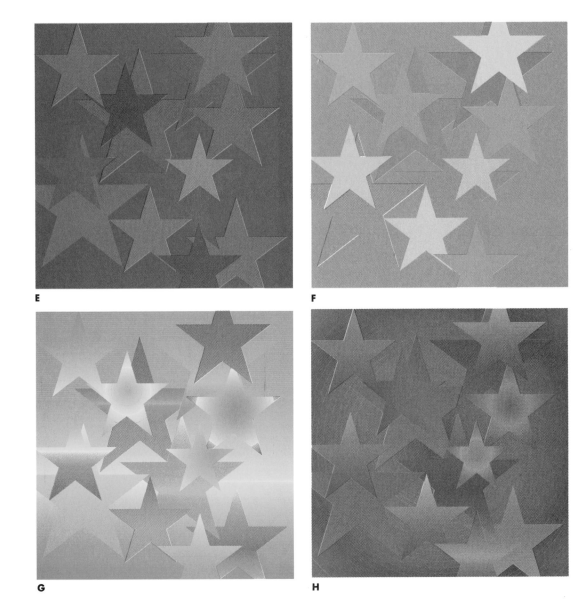

E

F

G

H

**7**

SPACE AND VOLUME

2-3 times, then reduce.

**98**

We usually start working with shapes that are flat planes. Then we can fill them, distort them, or relate them in certain ways to create the illusion of space and volume.

Spatial illusion can easily be created by filling a shape and/or its background with a gradient. Furthermore, we can modify the shape by slanting it or curving some of its edges. These operations alter the appearance of flatness or move the shape to an oblique position in relation to the picture plane represented by the surface of the monitor screen, or by the paper surface if the composition is finally printed.

To give volume to a shape, we can simply stack shapes or add strips of narrow shapes along some of the central shape's edges to establish thickness. We can also use several planar shapes to construct a three-dimensional form.

Addition of shadow can enhance the feeling of depth. Slanting shadows are effective to extend depth in a design.

Blending lines with curves and bends creates a surface with wrinkles or folds, and blending shapes creates a volumetric form.

## INTRODUCING CURVATURE

A linear gradient can be used to introduce cylindrical curvature to a flat shape. We can create progressively changing shades from side to side in one direction (**A**) or from the center to the two sides (**B, C**). Filling the background with a gradient further enhances the spatial illusion (**D**).

The linear gradient inside a shape can be rotated (**E**). We can also repeat a gradient-filled shape, with or without resizing it, to form different compositions (**F–J**).

Replacing the linear gradient with a radial gradient establishes spherical convexity or concavity. Normally we use radial gradients in round shapes (**K, L**). The shape can be embedded in the background if the shade near the circumference matches that of the background. Three-dimensional effects can be achieved by offsetting the center of the radial gradient in the shape and adding another gradient fill to the background (**M, N**).

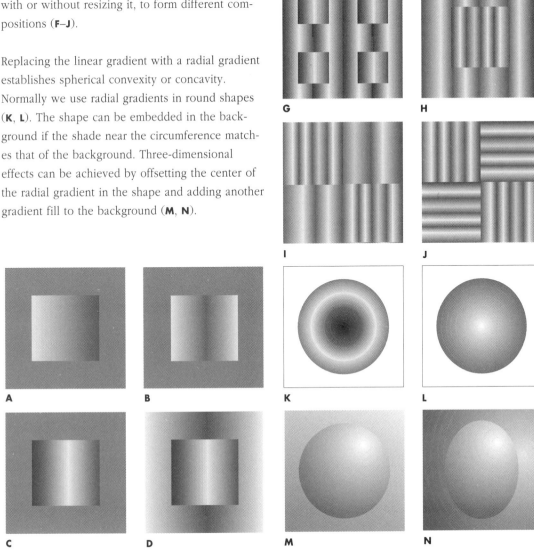

E

F

G

H

I

J

A

B

K

L

C

D

M

N

## RIPPLING A SURFACE

**100**

Bright and dark shades can be juxtaposed in a linear gradient fill to establish a rippling surface in any desired orientation (**A**, **B**).

We can reflect a copy of the shape to form a symmetrical arrangement (**C**) or arrange reflected and repeated versions in a composition (**D–E**).

A radial gradient fill can provide similar rippling effects (**F**). However, as we first draw an ellipse, the radial gradient filling it may not spread elliptically (**G**). If this is the case, we can start with a circle and add the fill and then group the shape and change it into an ellipse (**H**). In this way we can scale, rotate, reflect, and skew the shape, and the fill will conform to the transformation. We can repeat the transformed shape for any arrangement (**I**). We can even crop and repeat the shape to attain a composition (**J**).

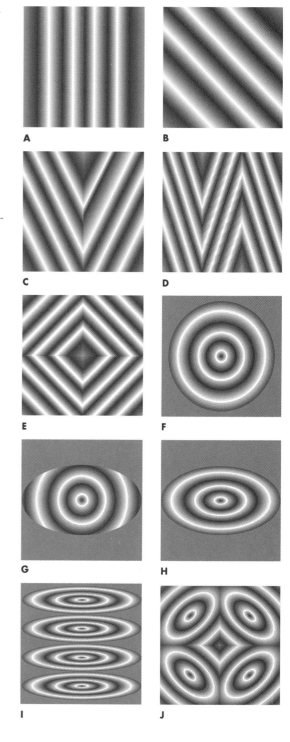

A

B

C

D

E

F

G

H

I

J

## BENDING OR CURLING A SHAPE

A rectangular plane appears flat. Using the *add-points* command to add middle points between existing points (**A**), we can select the top and bottom middle points and move these up or down simultaneously. Then the shape appears bent (**B**).

A better way to achieve bending is to skew the rectangular shape (**C**) and reflect a copy of it in a different fill horizontally (**D**). After grouping the resultant bent shape, we can repeat and reflect it in any way, even refill and skew some of the units to create spatial illusion (**E**, **F**).

With the rectangular shape containing added points, we can convert those points at the middle of the upper and lower edges to curve points and move them downward. The shape then appears curled (**G**). The curling effect can be enhanced with a linear gradient fill (**H**). A stronger spatial illusion can be achieved by rotating a copy of the resultant shape, filling the copy with a darker gradient, sending it to the back (**I**), and then distorting each shape individually (**J**).

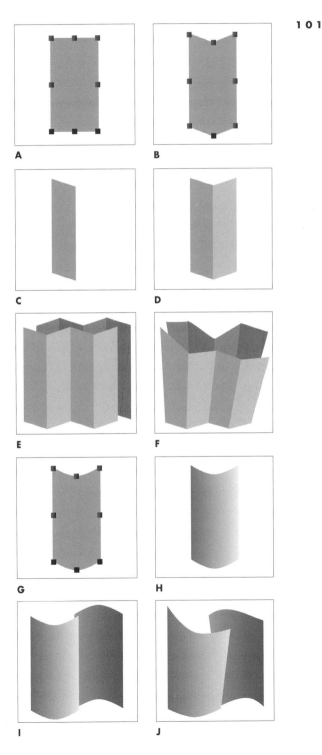

A     B

C     D

E     F

G     H

I     J

## STACKING SHAPES

**102**

Stacking repeated shapes can suggest volume even though they are separated by some degree of empty space.

Starting with an ellipse that is stroked black but not filled, we can clone a copy, move it upwards, and duplicate the move to create several ellipses stacked together (**A**). All the ellipses overlap one another transparently (**B**). We can select all and fill them white (**C**) or stroke them black and apply a gray fill, showing the stack with the latest copy on top (**D**). The fill can then be changed to a linear or radial gradient (**E**, **F**), and we can clone the top copy and give it a different fill (**G**).

Similarly, we can use a square shape for stacking and then rotate, reflect, skew, resize, stroke, and fill in different ways (**H–N**). Stacking effects can also be achieved even more efficiently with blending.

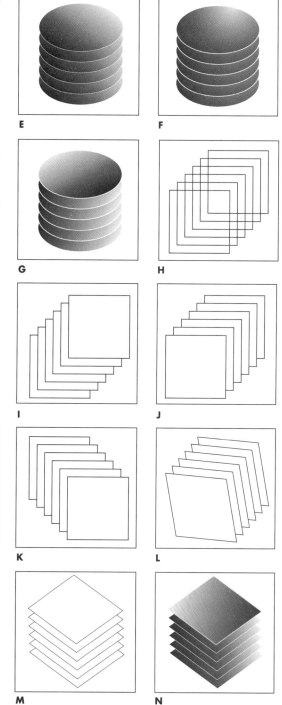

E

F

G

H

I

J

A

B

K

L

C

D

M

N

## RECEDING SHAPES

A rectangle can be changed into a parallelogram, and then into a quadrilateral, with upper and lower edges in parallel. A copy of this is reflected. The two shapes are placed at the opposite ends of a frame of reference (**A**) and then blended in an appropriate number of steps so that there is no overlapping (**B**).

To create the illusion of spatial recession, we can repeat the entire blend, progressively reducing the size in up-shifted positions, and fill all shapes with a linear gradient (**C,D**). The resultant shapes convincingly suggest an arrangement of square floor tiles seen in a one-point perspective.

**A**

**B**

**C**

**D**

## ROTATING SHAPES

**104**

Positioning one side of a rectangle contiguous with one side of a parallelogram, we can then blend the two shapes that are filled with different gray shades and stroked with the same light gray shade (**A**, **B**).

Blending produces intermediate steps that suggest rotation of planes along an axis. To create a composition, these are grouped as a unit for repetition and reflection, with slight change in the fills (**C**). Then we can resize the selected elements to form another composition (**D**).

To achieve the illusion of a 360-degree rotation in space from front to back, we can blend a shape in full frontality with a shape that is seen at its edge, appearing almost like a line. We can arrange the shapes in two different relationships (**E**, **F**) and blend them to create illusions of a 90-degree rotation (**G**, **H**). The two blends are subsequently brought together to form the illusion of a 180-degree rotation (**I**). The lower blend is then resized (**J**), and its front unit is moved slightly to create a perspective of distance in viewing the entire blend (**K**).

A copy of the group can be reflected horizontally (**L**). Putting the original group and its reflected copy alongside, a 360-degree rotation is now achieved (**M**). Grouping again, we can resize and repeat the new, larger unit to create a composition on a black background (**N**).

**A**                    **B**

**C**

**D**

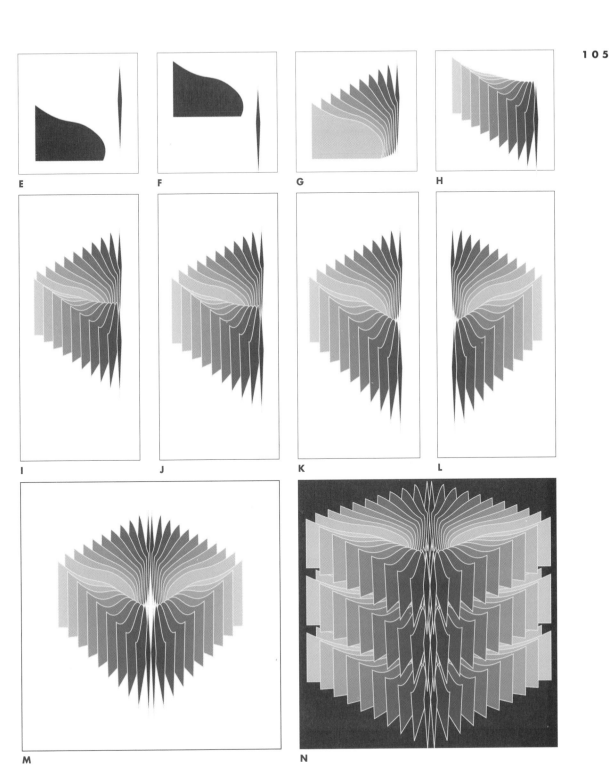

E

F

G

H

I

J

K

L

M

N

## ADDING SHADOW TO A SHAPE

**106**

A flat shape (**A**) can become a floating shape in space if we place a copy in a different shade behind it, suggesting a shadow (**B**). Skewing the shadow, the shape now appears to be standing on a slightly inclined ground (**C**). The illusion is enhanced by changing the shadow to a linear gradient (**D**).

Skewing a shape shifts its frontality, and adding an oblique shadow emphasizes its free-standingness (**E**). The three-dimensional illusion is further strengthened by changing the solid fill to a gradient fill in the shadow (**F**).

We can repeat the shape and shadow combination several times to form a composition with illusory effects (**G**).

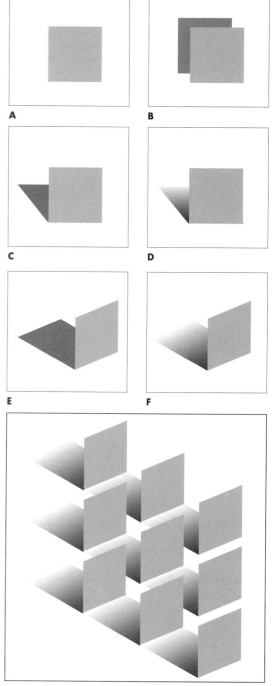

A

B

C

D

E

F

G

## ADDING THICKNESS TO A SHAPE

A shape acquires thickness when side planes are added to selected adjacent edges.

If we start with a square, we can ungroup it and clone a copy to its left side (**A**), select two points of this copy at the far left edge, and drag to form a narrow parallelogram to represent one part of the shape's thickness (**B, C**). Then we clone another copy, select two points of this copy at the lower edge, and drag to form another part of the shape's thickness (**D**). Subsequently we fill the form and stroke with "none" (**E**). The two parts of the shape's thickness can always be adjusted, if necessary (**F**).

With the right configuration and visual attributes, we can repeat it a number of times to create a composition (**G**).

C

D

E

F

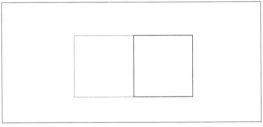

A

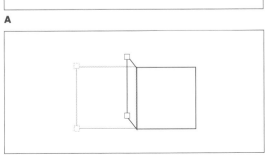

B

G

## ESTABLISHING VOLUME

**108**

Starting with a parallelogram, we can construct a cube with all oblique planes by dragging points on cloned copies (**A**, **B**). The cube can then be rotated or reflected, skewed, resized, and given different fills (**C–F**). We can use all the varieties of this cube to create a composition (**G**).

In the same way that we formed a cube, we can construct a prism of any height and direction (**H–K**). The placement of two or more prisms that convey the illusion of three-dimensional shapes (**L**, **M**) can be used to create compositions with illusory effects (**N–P**).

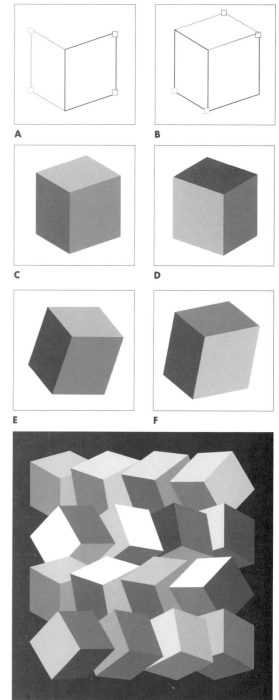

A    B

C    D

E    F

G

**H**

**I**

**J**

**K**

**L**

**M**

**O**

**P**

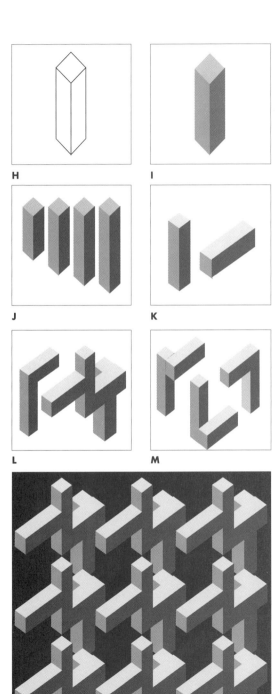

**N**

## MULTIPLE VIEWS

**110**   Three-dimensional shapes can appear to be different configurations when seen from different distances and angles. We can use use the rotate, reflect, scale, and skew tools to perform changes to a cube (**A–C**) and to prisms (**D–F**).

Multiple views of the same three-dimensional shape may sometimes seem unnatural, but the resultant composition can show a special spatial expression (**G**, **H**).

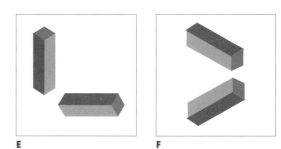

**E**

**F**

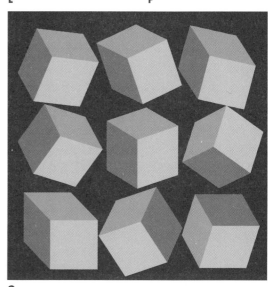

**G**

**A**

**B**

**C**

**D**

**H**

## CONFLICTING VIEWS

The unnaturalness found in multiple views can be further emphasized. In one composition we can have a shape seen from the right and top, and a similar shape seen from the left and bottom, intentionally creating spatial conflict resulting in a jarring vision (**A**, **B**).

In fabricating a three-dimensional shape with separate planes, we can integrate conflicting views by changing the normal layering order of the constituent elements (**C–H**).

Conflicting views can be used to draw attention. We can repeat units, rotating and reflecting them to obtain different conflicting views in a composition (**I**), and we can use shapes with integrated conflicting views (**J–M**).

C

D

E

F

G

H

A

B

I

112

J

K

L

M

## TRANSFORMING A SURFACE

Blended parallel lines can suggest a flat surface parallel to the picture plane (**A**). Blended bent lines can suggest a surface with folds or creases (**B**). Converting a selection of corner points to curve points "wrinkles" the surface (**C**). Duplicating the blend adds a layer. Each layer can then be separately manipulated or separately stroked (**D**, **E**).

The surface can have lines showing a diagonal direction. Starting from a zigzag line at the bottom, we create a diagonal straight line to indicate the middle of the blend, and another zigzag line near the top (**F**). After blending the lines (**G**), we can adjust the shape by moving and converting points (**H**, **I**). We can clone the blend to create two layers, and we can duplicate a differently stroked layer (**J**).

We can create a part folded to the back of a plane forming the surface. With two lines in a backward loop (**K**), we can split each line at the turn of the loop (**L**), blend each set of lines separately but in the same way, first in just a few steps (**M**, **N**), and then in a desired number of steps with necessary manipulations (**O**, **P**). To complete the fold illusion, the set of shorter lines is placed at the back and both sets of blends can be duplicated and then given new visual attributes (**Q**).

To create a plane folded in another way, we can start with a single straight line and drag copies from it, in a sequence, to predetermined locations (**R**). These lines should be differently stroked (**S**), so that their blending makes noticeable spatial effects (**T**). We can later change selected straight lines to curves (**U**, **V**).

To achieve a woven fabric effect, we first create zigzagged lines and then apply duplications, rotations, resizing, shifting of elements, varied gray shades in the stroking, and conversion of point to smooth or sharpen blends (**W–Z**).

**113**

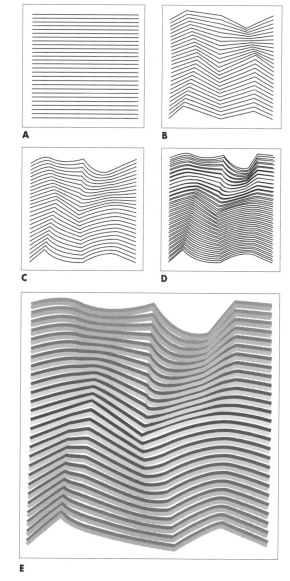

A

B

C

D

E

**114**

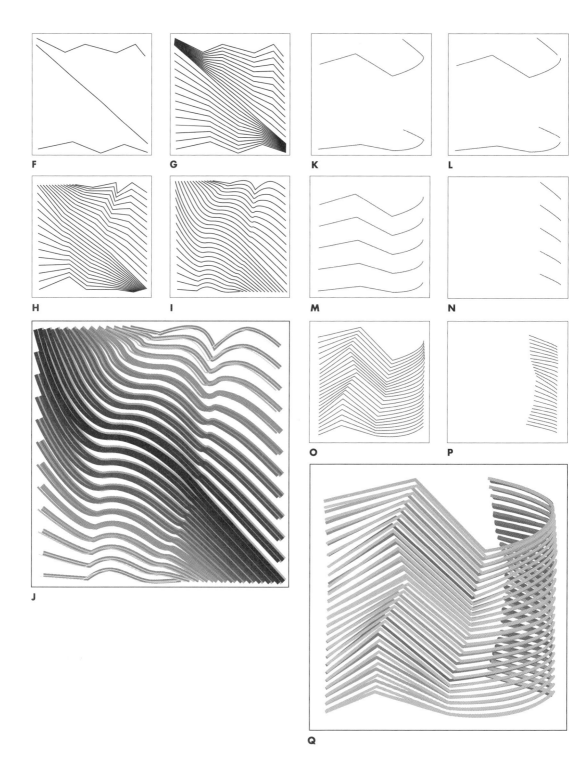

F

G

K

L

H

I

M

N

J

O

P

Q

R

S

W

X

T

U

Y

V

Z

## TRANSFORMING A VOLUME

**116**

We discussed how to blend closed paths in Chapter 4 and geometric planar shapes in Chapter 5. We can achieve illusory volume in both instances. Starting with three rectangles, we rotate them individually (**A**, **B**), and after ungrouping, move each point on the rectangles to change them into quadrilaterals that suggest square shapes seen in two-point perspective.

Blending the separately stroked and filled quadrilaterals (**C**), we now have a stack of shapes, with the lowest shape at the front of the stack (**D**). By selecting the topmost shape and sending it to the front, the stacked shapes clearly suggest volume (**E**) We can attain a twisting effect by moving points on the middle shape in the stack (**F**). We can strengthen the illusion of volume by increasing steps in the blend (**G**).

We can also blend three ellipses (**H–K**) or two ellipses and one rectangle (**L–O**) in a similar procedure, with similar effects. Furthermore, we can blend complicated shapes and perform additional manipulations (**P–U**). The blended shape can be distorted to any degree (**V**), or repeated many times in a composition (**W**).

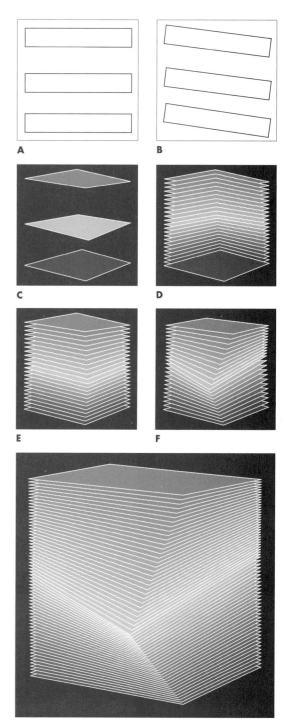

A

B

C

D

E

F

G

H

I

L

M

J

N

K

O

118

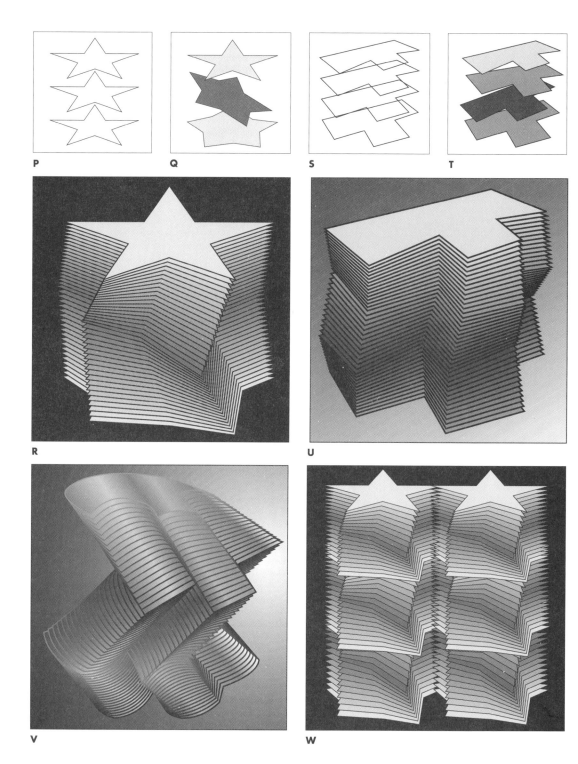

P

Q

S

T

R

U

V

W

## SUGGESTED EXERCISES

Adding the illusion of space and volume and creating visually conflicting views open new horizons in visual design. The following exercises can help the reader become proficient at accomplishing such goals:

- Open a new document. Draw a square or rectangle, and fill it with a gradient with multiple gray shades (**A**). Resize, repeat, and rotate the shape to obtain several stripes (**B**). Skew the group (**C**) and rotate a copy to form a hollow cube (**D**). Darken selected gradient fills with available commands or filters to enhance the spatial illusion (**E**, **F**). Use the units obtained to form a composition, with some grouped stripes brought forward or sent to the back to create visual conflict. Save the document as **Exercise 7.1 (G)**.

- Resave the document as **Exercise 7.2**. Delete all elements except one group of stripes. Stroke them in black, in a thin line weight, and fill them with flat gray shades. Use the group to construct different configurations of folded and joined planes (**H–M**), then use selected units to form a composition on a ground filled in black (**N**).

- Resave the document as **Exercise 7.3**. Delete all elements except one single stripe. Repeat the stripe several times (**O**), fill the resulting stripes with different flat gray shades, and blend them in appropriate number of steps (**P**). Select and modify individual units so that the blend conveys a twisted form (**Q**). Add points to bend selected paths (**R**). Repeat and rotate the units, adding further modifications if desired, to create a composition on a gradient-filled ground (**S**).

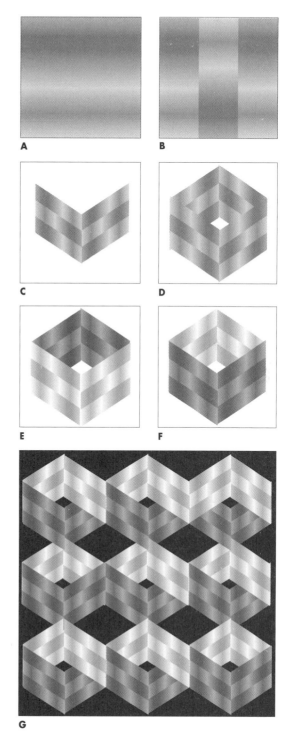

A

B

C

D

E

F

G

**120**

H

I

J

K

L

M

O

P

Q

R

N

S

# 8 TYPE AND FONTS

**122**

Type is a major source of ready-made shapes in visual design. Type takes configuration as fonts, which are designed with varying purposes in mind: legibility, aesthetic considerations, and/or conveying moods, spirit of eras, associations with particular activities, trades, professions, or social groups, and energy levels. The characters comprising a font include letters, numerals, symbols, and punctuation marks.

Every draw program contains a *type tool* with which we can originate type, as individual characters, or as words. Visual impact with type depends on the choice of font and determing how the characters are spaced within a word and between lines of words.

A single character may have the effect of an individual shape. A single word or a string of words may have the effect of a line. Lines of words forming a group or paragraph may constitute a plane.

Our primary concern here is to investigate possibilities of using the characters as visual elements in a design, and to explore visual expression of meanings of single words. Typography, or typographic design, is a highly specialized area and the focus of numerous other books.

## KINDS OF FONTS

Fonts fall in two main categories, the *serifed* fonts (**A**) and the *sans-serif* fonts (**B**). A serif is a short line or wedge shape appended to the starting or ending of a character to enhance the sense of horizontal flow and facilitate reading.

Serifed fonts convey a classical feeling, whereas sans-serif fonts tend to create a more contemporary look. In addition, there are fonts that closely simulate calligraphy and exhibit scholarly elegance (**C**), and brush writing fonts that emphasize casualness (**D**).

A large font "family" consists of a range of styles created by light, regular, bold, extra bold, and heavy versions, all with italicized versions (**E–I**). A condensed version may also be available (**J**).

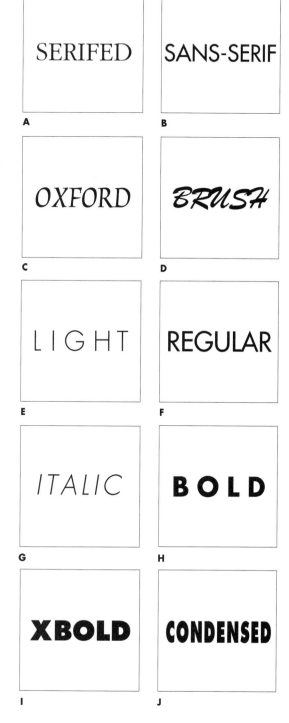

SERIFED

**A**

SANS-SERIF

**B**

OXFORD

**C**

*BRUSH*

**D**

LIGHT

**E**

REGULAR

**F**

*ITALIC*

**G**

**BOLD**

**H**

**XBOLD**

**I**

**CONDENSED**

**J**

## SINGLE CHARACTERS

**124**

The characters comprising each kind of font include letters in *capitals* and *lower case*, numerals ranging from 0 to 9, and a range of commonly used symbols and punctuation marks.

All characters sit on a *baseline*. Lower-case letters may be confined to a narrow, central area above the baseline called the *x-height* (**A**). Some letters will have as upward-moving strokes, *ascenders,* that go above the x-height area (**B**), and downward-moving strokes, or *descenders*, that go below the baseline (**C**).

Capitals and numerals occupy the x-height area plus the extended area made by the ascenders (**D**, **E**). Sizes and positions of symbols and punctuation marks vary considerably (**F**, **G**).

The size of characters is referred to as *type size.* Measurement of type size is based on the distance or *points* between the tallest ascender and the lowest descender in a font. There are 72 points to an inch.

Many single characters have unique shapes that can be used as design elements. Characters of certain san-serif fonts are similar to geometric shapes (**H**).

Characters can be stroked and/or filled with any flat color or shade (**I**). Individual characters can be rotated, reflected, skewed, repeated, resized, and moved to form a composition (**J**).

## CONVERTING TYPE TO PATH

Choosing the *type* tool in the toolbox and placing the cursor representing the tool in a desired location, we can hit a key on the keyboard to insert a character, or a sequence of keys to insert a string of characters. The character or string of characters can always be selected and changed to any other font in regular, bold, or italic style, and to a different size.

To effect transformations, the single character or string of characters can be converted into a graphic object, using a *convert-to-path* or *create-outlines* command. After the conversion, it becomes something that is composed of points and paths. We can stroke it (**A**), apply a linear or radial gradient with or without stroking (**B–G**), alter its contours by manipulating the points on the path (**H**), or distort it with a relevant filter (**I**, **J**). Results of all such changes and manipulations can be used for a composition (**K**).

A

B

C

D

E

F

G

H

I

J

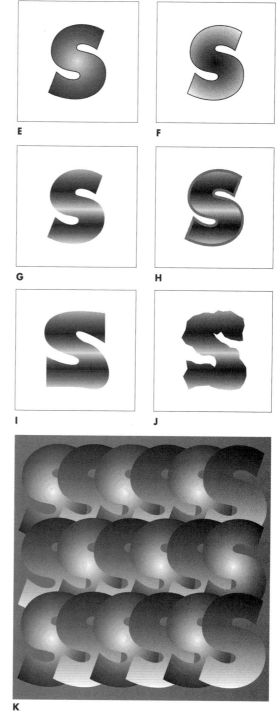

K

## UNITING CHARACTER SHAPES

**126**

Paths obtained from separately converted characters can be united to form a more complex shape (**A**). Subsequently we can slant it in different ways, using one skewed version for the shadow, and have the shadow in a gradient fill (**B–D**). The combination can became a unit for repetition (**E**, **F**).

On a ground filled with a radial gradient, rotation and further duplication and manipulation can create a composition expressing immense spatial depth (**G**).

**E**

**F**

**A**

**B**

**C**

**D**

**G**

## BLENDING CHARACTER SHAPES

We can blend two or more characters shapes (**A**) to create a volumetric form (**B**). Each of the elements used in the blending can be subselected, moved, and manipulated (**C**).

Suppose we need a form that has an overall squarish configuration. We can create this form by dragging individual points or segments to achieve a reshaping (**D**). The resultant form can be further modified by sending the front shape to the back or bringing the rear shape to the front and then increasing the steps in the blend (**E**).

Finally, we can duplicate and rotate the form to experiment with a variety of compositions (**F**, **G**).

**D**

**E**

**F**

**A**

**B**

**C**

**G**

## SYMBOLS AND DINGBATS

**128**   There are certain fonts that feature symbols for special usage (**A**, **B**) and/or dingbats, ornamental elements or tiny pictures that serve as signs (**C–E**). These can be accessed via typing on the keyboard and are also convertible to paths the same way.

A symbol or dingbat may contain enclosed space (**F**, **G**). After conversion to paths, all holes need to be filled separately (**H**, **I**), or joined to the main shape (**J**, **K**). Repeating the converted symbols or dingbats as units, using rotation and further manipulations, can produce interesting compositions (**L–N**).

**A**

**B**

**C**

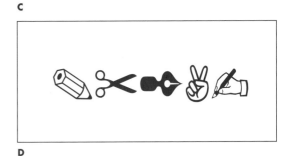

**D**

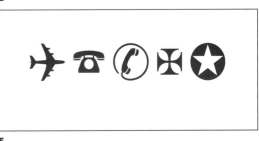

**E**

**F**

**G**

**H**

**I**

**J**

**K**

**M**

**L**

**N**

## CHARACTERS FORMING LINES

**130**

A sequence of characters from any kind of font can be seen as a line (**A**). Between one character and the next is a *letter-space*. The entire length of the line of characters can be reduced or extended by decreasing or increasing the *tracking* value in the control palette to compress or widen all the letter-spaces uniformly (**B**). This operation, which can be effected just between two characters, is sometimes called *kerning* (**C**).

In the character sequence, we can select any single character with the type tool to change its size, style, font, color and/or shade, and do so alternately to form a patterned band, if desired (**D**, **E**).

We can duplicate the line of characters in a different shade and combine the two lines into one by laying one line on top of the other (**F**).

Without converting the line of characters into paths, we can clone, resize, skew, rotate, and/or reflect (**G**), and use the results as units for a composition (**H**, **I**).

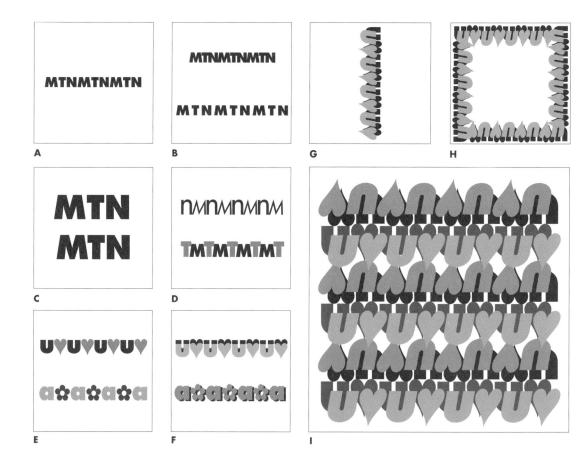

A

B

G

H

C

D

E

F

I

## CURVING A LINE OF CHARACTERS

A line of characters can be joined to any open path (**A**). The characters normally rotate around the path if the path is curved (**B**). We can move any point and handle on the path, add more points to it, or delete any existing point (**C**).

It might be possible to have all the characters vertically upright (**D**) or vertically skewed (**E**). The latter operation produces the illusion of a ribbon-like plane. This can then be resized and repeated to enhance the effect (**F**, **G**).

The line of characters can also be joined to a closed path, such as a circle or ellipse (**H**). If there are not enough characters to form a full circle (**I**), we can add more characters by typing to the line or by increasing the tracking value (**J**).

With duplication and/or resizing and change of visual attributes, we can group lines of characters as units (**K**, **L**) for different attempts in compositions (**M**, **N**). Despite all these operations, the characters remain as type; they have not been converted to paths.

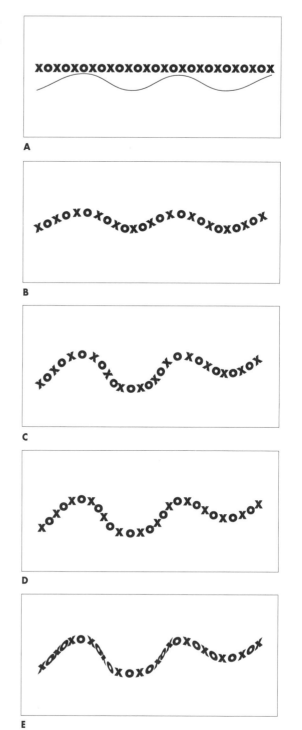

A

B

C

D

E

132

**F**

**G**

**H**

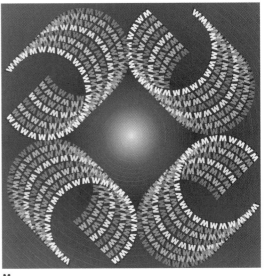

**M**

**I**

**J**

**K**

**L**

**N**

## WORDS AS VISUAL EXPRESSION

When characters form a word that can be read, the meaning of the word may also be conveyed visually by the font, the letter-spacing, size and position in relation to the frame of reference, the way characters are manipulated, and/or the background (with or without additional elements).

The illustrations here using only type feature the words "narrow" (**A**), "wide" (**B**), "big" (**C**), "small" (**D**), "thin" (**E**), and "thick" (**F**); the last one has a heavily stroked copy lying to its back.

The words "fold," "cut," "torn," and "lock" are created by type converted to paths. A knife tool has been used to slice the elements (**G–J**).

Additional elements were added to the words "look," "love," and "rain" (**K–M**). Distortion filters were applied to the words "distort," "mountain," "water" and "perspective," with gradient fills used in some instances (**N–Q**). Very similar gradient fills have been used for the word "fog" and the background (**R**). Repetition, rotation, and/or reflection of elements was used in the words "reflect," "shadow," "cross," "step," and "layer" (**S–W**).

A  B

C  D

E  F

G  H

I  J

**1 3 4**

**K**

**L**

**U**

**M**

**N**

**O**

**P**

**V**

**Q**

**R**

**S**

**T**

**W**

## COMPOSITION WITH WORDS AS UNITS

A word that also expresses the meaning visually can be used as a unit for further development in a composition. Using the word "look," eyeballs inside the two O's have been varied in their positions so that action is somewhat implied (**A**).

With the word "rain," diagonal white lines of different densities and a background in a slanted gradient fill help to communicate the feeling of heavy downpour in stormy weather (**B**).

The word "perspective" has been progressively stretched in each repetition to suggest the illusion of objects reaching back into deep space (**C**).

Compositions featuring the words "layer," "fog," "step," and "shadow" are further examples (**D**–**G**).

A

B

C

**136**

D

E

F

G

## ADDING A TITLE TO A COMPOSITION

A composition may require the addition of a title, which could be either a single word or a string of words.

With words as units carrying a visual expression, we can have one unit stand out slightly more than others to function as a title (**A**, **B**). If the words are not legible, then a separate title of appropriate legibility may help the communication (**C**, **D**).

If we use all abstract or non-representational elements to express an intended meaning, a title can communicate the meaning with clarity (**E**, **F**).

Titles as character forms are important visual elements, as they often become focal points in a composition.

A

B

**138**

C

E

D

F

## SUGGESTED EXERCISES

The previous chapter on space and volume can serve as a guide for the exercises in this chapter. Words such as "space," "volume," "depth," "illusion," "curvature," or any other term in the text may be chosen to feature in a composition. Note that the procedure of saving and resaving documents will no longer be mentioned.

- Choose a single word and use it repeatedly, with or without transformation, in two or more different compositions, with its meaning expressed in the visual shapes (**A**, **B**).

- Use abstract or representative elements to express the meaning of a chosen word, and add the word as title to the composition. Attempt two or more compositions (**C–F**).

**A**

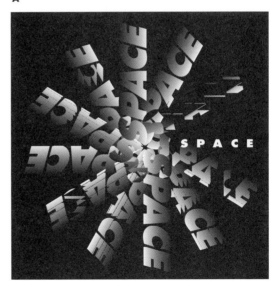

**B**

**140**

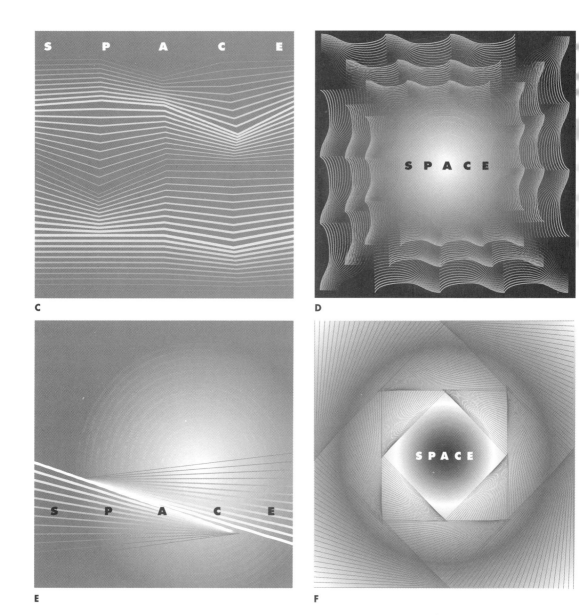

C

D

E

F

PATTERN AND TEXTURE

9

**142**

A closed path can be filled with a flat shade, a gradient, a pattern, or a kind of texture. The use of pattern fills was demonstrated to a limited degree, and the use of texture in a fill has not yet been discussed.

Simple pattern fills are usually made up of simple square bitmap dots. The dots can be easily edited. For more complicated pattern fills, a draw program usually allows us to create a unit for use as a tile, which can be automatically repeated in a grid arrangement to form a pattern fill in a selected shape.

Sometimes a pattern can be interesting enough to form the entire composition. To achieve more complicated effects, however, different patterns can be applied to different shapes and to the background as well.

A bold pattern formed with relatively large elements can distract from the containing shape. The visibility of the shape is reduced—although this effect sometimes adds interest to a design.

A fine pattern can be considered to be a piece of texture when constituent elements do not stand out as individual shapes but merge to form a surface. Texture does not normally show obvious repetition of elements and may contain slight irregularities.

The distinction between *pattern* and *texture* is not always clear. Whether the fill is seen as a pattern or piece of texture does not really matter, as long as it is appropriate for the composition and meets our goals.

## SIMPLE PATTERN FILLS

A simple pattern fill features square bitmap dots in an arrangement that repeats to form a regular pattern inside the containing shape.

There are sixty-four dots (**A**), in either black or white, forming a unit in an eight-by-eight-unit grid arrangement (**B**) that is repeated to establish a pattern (**C**). The resolution follows that of the monitor display, usually 72 dots to an inch.

A pattern obtained in this way may not permit many variations. Stock patterns in striped, crisscross, and checkerboard patterns, as well as interesting shapes, are built into the program and can be selected in the fill palette (**D–R**).

All of such patterns can be inverted, and the black dots can be changed to any color or gray shade, but the white dots remain white and opaque (**S–X**). Thus a shape with any pattern fill can block whatever lies behind (**Y**).

B

C

D

D

E

G

H

A

**144**

I

J

S

T

K

L

U

V

M

N

W

X

O

P

Q

R

Y

## CREATING NEW BITMAP PATTERNS

If no stock pattern meets our needs, we can create a new bitmap pattern. Reaching for the box containing the eight-by-eight-dot grid in the fill palette, we can use the pointer tool to convert a black dot into a white dot, or vice versa, of a chosen stock pattern. Or we can clear all dots and insert dot by dot, observing the development of the pattern.

New patterns generally show right-angled shapes in a vertical/horizontal arrangement (**A–H**). They may appear to be diagonally placed or triangulated (**I–Q**), or suggest organic or irregular shapes (**R–Z**).

A

B

C

D

E

F

G

H

I

J

**146**

K

L

S

T

M

N

U

V

O

P

W

X

Q

R

Y

Z

## APPLYING PATTERN FILLS

Pattern fills can make a flat shape look less solid. A shape with a dotted or striped black pattern can seem grayish, appearing similar to a flat gray shade (**A**).

When two adjacent shapes are filled with the same pattern, they become indistinguishable. Editing the pattern of one, we can make the two shapes slightly distinct but somewhat merged (**B**). Filling the background with the same pattern differently edited, we can minimize visibility of the shapes to convey a sense of interesting blurry vision (**C**, **D**).

Vibrating optical effects are attainable with different combinations of generally similar pattern fills (**E–K**).

A

B

C

D

E

F

G

**1 4 8**

H

I

J

K

## TILED FILLS

We can start by copying one element or a group of elements (**A**, **B**) for pasting to the tile box of the fill palette to effect a tiled fill to a selected shape (**C**, **D**). In the fill palette, we can resize the elements and rotate the fill (**E**). Because the background between the elements is transparent, we can clone a copy of the shape in front, fill it in some way, and send it to the back (**F**).

The element created to form a tiled pattern can have a gradient fill (**G**, **H**). After reducing the size of this element, we can place an additional layer with the same fill in front and change the direction of the fill, thus making a denser fill with more background showing through (**I**, **J**).

A more solid fill can be created if we group elements closely (**K**) and crop them with a rectangle (**L**, **M**). Then we can resize the elements (**N**, **O**) and rotate the fill, if desired (**P**). The background can also contain a tiled fill in a composition (**Q**).

Characters as type can be converted to paths, filled with a gradient, and used as elements for a tiled pattern to fill a selected shape (**R**, **S**). Alternatively, instead of filling the shape with a tiled pattern, we can fill it with a gradient, lay it on a background filled with a gradient in a different way, and get another shape for a tiled fill as large as the entire area of the background, which acts as a semitransparent veil on top of everything (**T**, **U**). In this case the tiled fill should contain open gaps between elements to allow all that is beneath it to show through.

A

B

C

D

E

F

G

H

I

J

**150**

K

L

R

S

M

N

T

O

P

Q

U

## BUILDING TEXTURE IN A FILL

Repeating elements tends to emphasize the strong regularity of a pattern. We can, however, superimpose two or more layers of the same tiled fill to build texture. A group of blended straight lines (**A**) can be used to fill successive layers of the same shape to attain a textural effect (**B**, **C**).

Using type as textural elements displays less obvious repeats. We can crop a group of characters to ensure an even spreading in a tiled fill (**D**). Then, on a copy of the shape that is gradient-filled, we can successively rotate the characters of the fill (**E**). With the background in tiled patterns as well, we can create compositions that are rich in texture (**F–H**). We can also add layers of different tiled fills (**I–K**).

**152**

H

J

I

K

## SUGGESTED EXERCISES

The following exercises cover three aspects of creating pattern and texture: the use of bitmap patterns, the use of tiled patterns, and the creation of textures with tiled patterns.

• Convert two or more characters to paths and use the group as a united shape to hold bitmap pattern fills (**A**). Try using different bitmap patters for the shape and the background to attain high clarity (**B**) as well as low recognizability (**C**, **D**).

• Change the fill of the shape to a gradient and use as a unit for tiled fills (**E**). Also try to use some other characters to form a unit for another kind of tiled fill for the background (**F**). Tiled units for the shape should be larger than those for the background (**G**).

• Change the units so that they are stroked but not filled. Select different versions of white, black, or gray strokes (**H–K**) and use them to create multilayered tiled fills in both the shapes and the background to achieve an overall feeling of rich texture in the compositions (**L–N**).

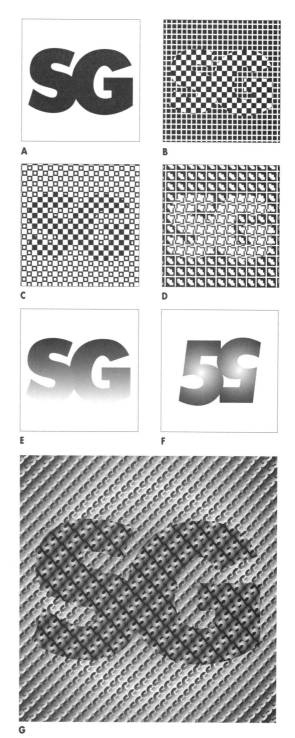

A

B

C

D

E

F

G

**1 5 4**

H

I

J

K

L

M

N

RASTER IMAGES

10

**1 5 6**

A draw program creates vector graphics, which are mathematically defined by precise dimensions, sharp edges, and solidly flat or smooth graduated fills. It is not meant for creating raster images, which are bitmapped, composed of fine dots arranged in a grid, with *antialiased* edges that show no saw-tooth distortions.

Raster images are either photographs, scanned pictures of prints and flat materials, or shapes, visible marks, colors, and shades created within a paint or image-editing program. They can be of high resolution, and various commands and filters within the program can be applied to create innumerable modifications.

We can import raster images from an image-editing program or a paint program into the draw program, transform or manipulate them like most planar shapes, and use them as components for a composition. To facilitate transfer, such images should be saved in a *TIFF*, or *tagged image file format*, which maintains considerable high resolution and can be opened by most graphic programs.

Some draw programs allow conversion of selected vector graphics into raster images. Most of the techniques discussed in this chapter, however, require an image-editing program and a scanner. A digital camera can capture directly images in our daily environment for computer use. A paint program can produce effects of drawing and painting in various media on a variety of materials. Both are helpful but not essential.

## RASTER IMAGES AS PHOTOGRAPHS

Photographs constitute the main category of raster images. They come from two sources: a digital camera or a scanner. Once the full image is displayed on screen in an image-editing program, we may need to do some initial editing.

For the purpose of visual design, we probably have to determine whether we will use the entire photograph (**A**, **B**) or only a portion of it (**C–F**). Naturally, resolution of the image is reduced if it is cropped and subsequently enlarged back to its former size.

The next step in editing may be adjustment of lightness and contrast to bring out details and improve clarity (**G**, **H**). Further operations may include color balance, sharpening, and retouching of details, but these are beyond the scope of this book.

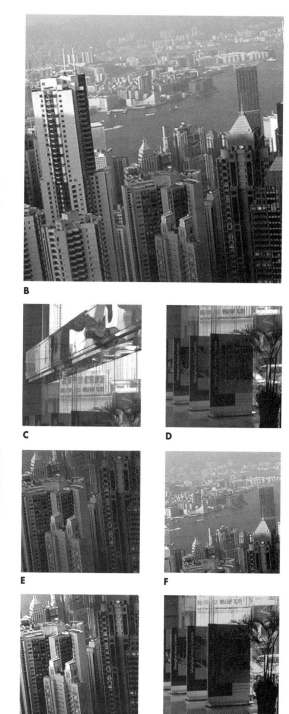

**A**

**B**

**C**

**D**

**E**

**F**

**G**

**H**

## RASTER IMAGES AS TEXTURES

**158**    Raster images can represent surface textures of
materials from nature or the man-made world
rather than shapes of objects. These are useful for
textured fills and can be photographs of flat objects
or surfaces at close range, or images obtained by
scanning flat material directly in a scanner.

Illustrations here show leaf veins (**A**, **B**), polished
marble (**C–F**), corrugated board (**G**), knitted woolen
yarn (**H**), and bubbled plastic sheet (**I**). They tend
to appear as abstract images, although most of
them are fairly recognizable as specific material
surfaces.

F

A

B

C

D

E

H

G

I

## RASTER IMAGES IN PAINTED EFFECTS

We can use a brush tool, spray tool, or other tools
in an image-editing or paint program to create
raster images directly on screen (**A**, **B**).

To effect repeats and sharp-edge shapes, we can
use a marquee tool to select and move portions, as
copies, from one place to another, resulting in
complete rearrangement of the composition (**C–E**).

Instead of direct painting on screen, we can use
painted pictures that have more details for scan-
ning (**F**, **G**). Similarly, we can photograph full-size
painted work with a digital camera for transference
to the program (**H**, **I**).

A        B

C

D

E

160

F

H

G

I

## RASTER IMAGES IN BLACK AND WHITE

Before transferring raster images to a draw pro-
gram, they should be fully edited or manipulated
within an image-editing program with the available
specific tools, filters and commands. For instance, a
grayscale photograph with a full range of tones can
be easily converted into a black-and-white picture
(**A**).

Conversion is accomplished by changing the
grayscale mode into a *one-bit bitmap mode*, which
means that all the lighter grays of the photograph
are converted into white and all the darker grays,
into black. To preserve detail, it is often necessary
to darken some light areas, lighten dark areas, add
grain, and apply appropriate filters before the con-
version (**B–E**).

Black-and-white raster images can simulate pen
drawings. When they are imported into a drawing
program, the white area can be made transparent,
and the black area can be changed to any color or
gray shade, as we shall see later.

A

B

C

D

E

## TEXTURIZING RASTER IMAGES

**1 6 2**

Raster images can be texturized in an image-editing program. Texturization adds some degree of abstraction to the recognizable subject matter.

To texturize an image, we can simply add a layer of constructed or woven texture on top of it (**A**, **B**). Transparency of the layer can be adjusted to allow the image to remain visible.

We can also texturize by using appropriate filters that add exaggerated graininess to the image (**C**), simulate printed halftones (**D**), display painterly brushstrokes (**E**), show effects of textured glass (**F**), or reflections on a rippling water surface (**G**).

B

A

C

D

F

E

G

## MODIFYING RASTER IMAGES

**164**

Ccommands with related dialog boxes allow us to change colors and tones, brightness and contrast, as well as effecting tonal curve and level redistributions in a raster image to produce unusual results (**A**) that form the basis for further modification with filters (**B**, **C**).

Abstract raster images can also be modified. We can start with the positive version of a chosen image, for example, a surface detail of a marble (**D**), and invert it to a negative image at any time for further experimentation (**E**). If we are not concerned with representational subject matter, we can apply filters freely to achieve special visual effects (**F–I**).

B

C

A

D

E

F

G

H

I

## DISTORTING RASTER IMAGES

There is a range of filters within image-editing programs that can be applied to distort raster images. We can stretch and compress different parts of an image in various ways. Some distortions create zigzagged shifts, whereas some lead to spherical disfigurations.

With only mild distortion applied, the resultant image may still be quite recognizable (**A–C**). With strong distortion, the resultant image can become totally abstract (**D–G**).

B

C

A

**D**

**F**

**E**

**G**

## FURTHER MANIPULATIONS

**1 6 8**

We can duplicate the same image into two layers for separate manipulation. In their superimposition, the front layer should be made translucent to allow the back layer to show through, as desired (**A**, **B**).

The two layers can also make use of different images (**C**) that can be individually modified with filters or merged into one single layer for manipulation (**D**). In all instances, resultant images should be adjusted for brightness and contrast.

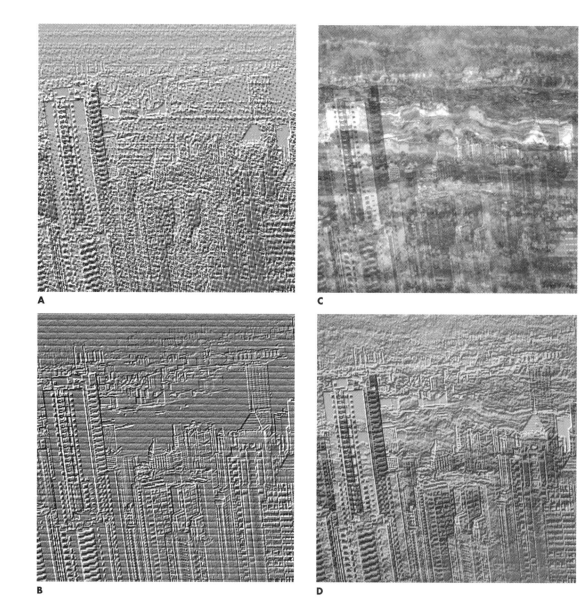

A

B

C

D

## SILHOUETTING AND CLIPPING

If the raster image is a self-contained object, it may have a surrounding contour and a simple background (**A**). We can use a wand tool to select the background and delete it, or fill it with white (**B**), changing it into a seemingly silhouetted shape. Importing the shape into a draw program includes the shape's background as well, which remains opaque and hides everything behind it (**C**).

Inside the image-editing program we can, however, select the background and invert the selection so that the shape is selected instead. Then we can convert the selection border into a clipping path. As we import the shape to a draw program, the clipping path is also imported. The shape now becomes a truly silhouetted shape that is not bound to any background (**D**). This shape can be resized, rotated, skewed, reflected, and/or repeated in a draw program (**E–L**).

The clipping path in an image-editing program can be in any shape other than its surrounding contour (**I**). All clipped images, path and content together, can be transformed or repeated to form compositions (**K–L**).

B

A

C

**1 7 0**

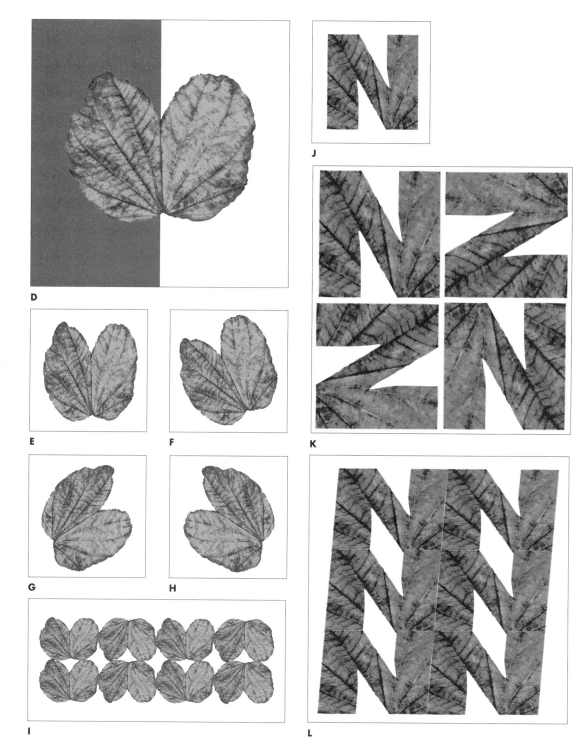

D

E

F

G

H

I

J

K

L

## WORKING IN A DRAW PROGRAM

Instead of clipping the raster image in an image-editing program, we can clip it in a draw program.

If the image is a one-bit bitmap image appearing only in black and white, we can change all white areas to transparent. Placing a closed path on top of the image, we can cut the image in the same way we would cut a vector object, and then select the path and place the image inside the path (**A**).

The path now functions as a clipping path. Clipping is the same as masking. What is outside the clipping path becomes invisible and transparent, but the full image is still there. We can move its hidden part into view, if necessary, if the path and its masked content have not been grouped as an integrated shape, and options for moving content and fill are unchecked in an associated control palette.

The integrated shape can be filled with any flat shade or a gradient, and the path can be separately stroked (**B**). For further manipulation, we can select the path and cut its clipped content. The black of the one-bit bitmap image can be changed to any shade, and, if desired, we can have the same image stacked in different shades, slightly offset, to give the appearance of a bas-relief. Subsequently we can paste back the image inside the path (**C**). A clipped image can be transformed and repeated, with or without variations, on different backgrounds to achieve different compositions (**D–J**).

**A**

**B**

**172**

C

E

D

F

G

I

H

J

## SUGGESTED EXERCISES

**174**  The following exercises provide experience in working with a draw program and an image-editing program to explore various possibilities of combining raster images with vector objects:

- Scan or photograph at close-up a real leaf or a printed leaf with prominent veins. Import this into an image-editing program. Crop a part and adjust brightness and contrast properly (**A**). Experiment with inverting it to a negative image (**B**), converting it to a black-and-white image after lightening or darkening (**C**), and other types of manipulations discussed in this chapter (**D–J**). Save results in a TIFF format as separate files for exporting to a draw program.

- Type one or two letters or numbers and convert the shape to a path. Use the path to clip different versions of the leaf image (**K–R**) and establish various compositions in a draw program (**S, T**). Save the compositions in separate files in the draw program.

- Export each composition to the image-editing program for texturization or distortion, and transfer the results back to the draw program for further editing, if desired (**U–X**).

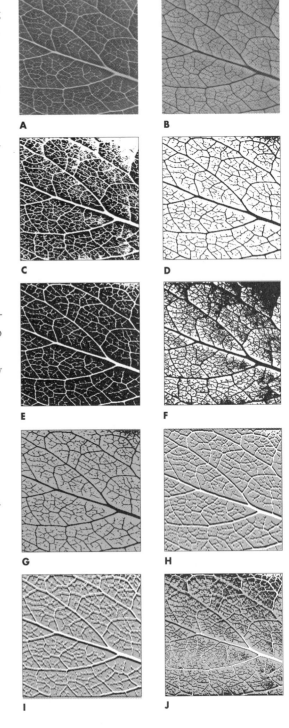

A  B

C  D

E  F

G  H

I  J

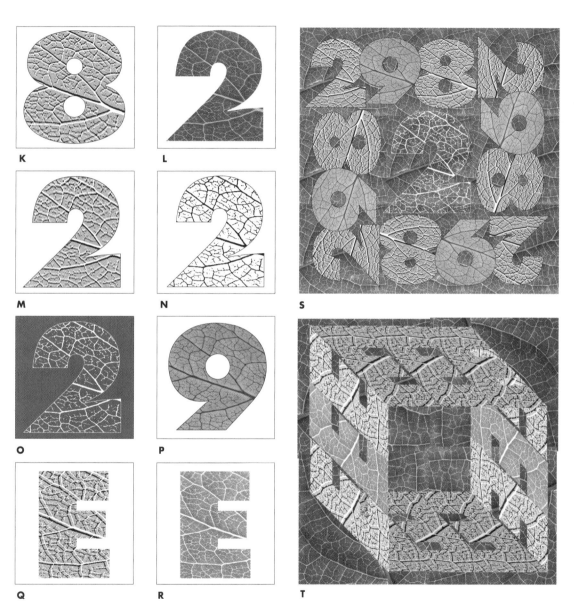

K

L

M

N

O

P

Q

R

S

T

**176**

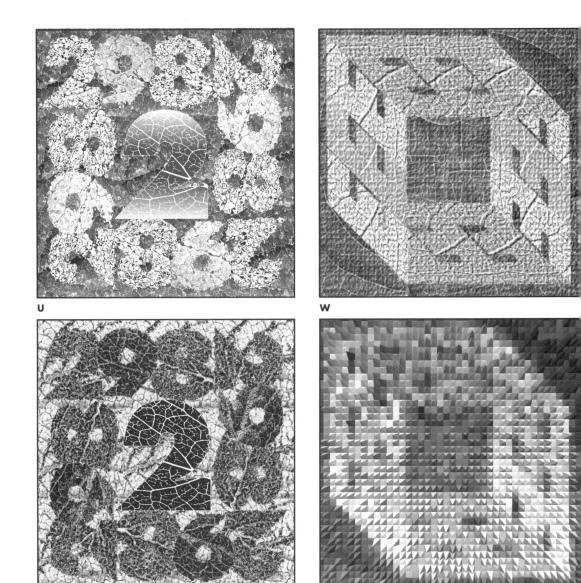

U

W

V

X

**11**

FORMAL COMPOSITIONS

A draw program relies on mathematical calculations. It is particularly suitable for creating elements or shapes that are regularly arranged to create a formal composition.

A formal composition features elements or shapes as repeated units in an arrangement with even distribution in space, successive rotation in the same angle, or progressive size changes. If more than one type of element or shape is used, their occurrences and variations should conform to a predictable order.

There are three basic types of formal compositions. The most common type consists of units repeated as row, column, or grid. A row is not necessarily horizontal, a column is not necessarily vertical, and a grid is not necessarily right-angled. A row, column, or grid of units can be rotated collectively in any direction.

Another type of formal composition is formed by repetitive units that are rotated at predetermined angles and in predetermined steps, showing the effect of radiating from a center. Units are usually arranged in a full revolution.

A third type is accomplished with units forming one or more polygonal or circular bands, resized and repeated with reference to the same center to achieve a series of expanding or contracting concentric rings.

## SIMPLE UNITS

All formal composition starts with a selected shape, which is then used as a unit for repetition. A unit that can be contained in one single closed path is referred to as a *simple unit*.

A simple unit can be created with any shape tool. It can be stroked and not filled (**A**), filled and not stroked (**B**), or both stroked and filled (**C, D**). It can also be created with a *type tool* that renders a symbol or character which, after conversion to a path, can then be stroked, filled, and manipulated like any other graphic shape (**E**).

Two or more units can be united into one single shape by using the *union* command. This operation links separate paths into one surrounding closed path. Thus the new shape is still considered a simple unit, regardless of its complicated contour or outline (**F**).

Uniting two simple units into one shape can sometimes lead to a hole in between (**G**). If the unit already has a hole inside, uniting two of this unit may result in a shape with two holes (**H**). Such new shapes can be seen as simple units as long as the fill area is unbroken.

We can also bring together two or more simple units without uniting them and use them as a group for further repeats. The group of simple units then becomes a *compound unit* (**I, J**).

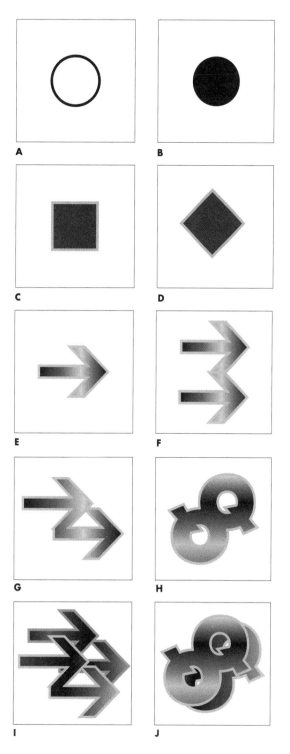

A     B

C     D

E     F

G     H

I     J

## COMPOUND UNITS

**180**

A compound unit consists of two of more shapes with independent closed paths that are grouped together repeatedly to create a composition.

The shapes forming the compound unit can be identical (**A**), of the same configuration but in different visual attributes (**B**), or of different configurations as well as visual attributes (**C**). They can stay separate (**D**), overlap (**E**), coincide (**F**), or touch one another (**G**).

We can repeat compound units (**H**) to form a larger unit and change the visual attributes of some of the elements (**I**). We can group different compound units, or combine compound and simple units, to attain a larger compound unit (**J**), which is subsequently repeated in a composition (**K**).

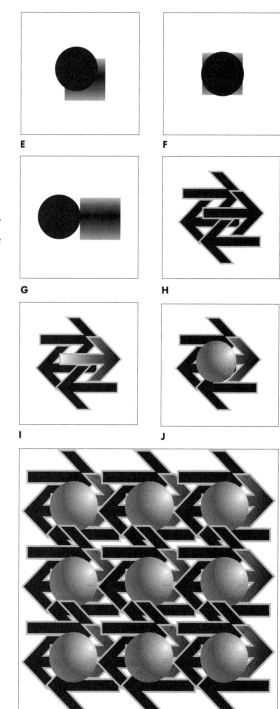

E

F

G

H

I

J

A

B

C

D

K

## INTERLOCKING UNITS

Repeating a unit usually places the copy in front of the original (**A**, **B**). Sometimes we may want to have one part of a front unit hidden behind the unit at the back. To achieve this, we need to clip a part from an extra copy of the rear unit, using a rectangular clipping path, to obtain an element (**C**, **D**) for laying on top of what actually lies behind. In this way, the two units look interlocked (**E**, **F**).

The same operation can be used to create an interlocking situation between two ring-like units (**G–J**). A string of ring-like units can be accomplished in a similar manner (**K**).

E

F

G

H

I

J

A

B

C

D

K

## REPEATING UNITS IN ONE DIRECTION

**182**

The easiest way to create a formal composition, is to create a unit (**A**), vary its visual attributes and orientation (**B–F**), choose a version, and then repeat it equidistantly in one direction. Different angles, directions, and distances can produce noticeably different results using the same units (**G–L**).

These units as a group can first be repeated to form a compound unit for further repetition. This may add an interesting complexity. Filling the background adds a finishing touch to the composition (**M**).

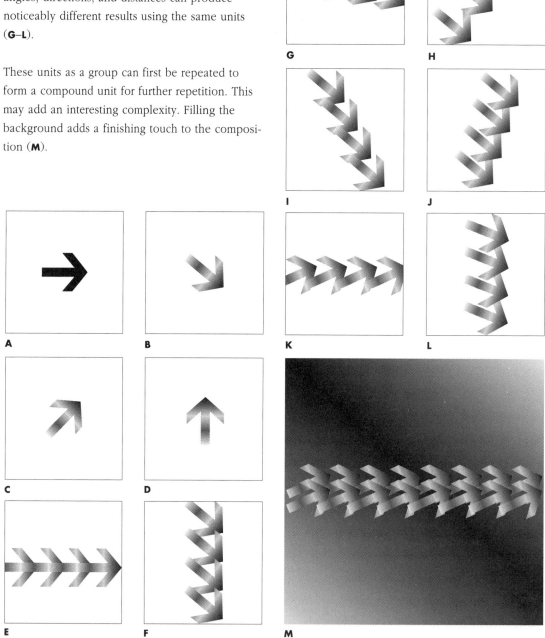

## REPEATING UNITS IN TWO DIRECTIONS

A row or a column of repeated units can be grouped and used like a compound unit for repetition in another direction.

The units are positive shapes that automatically define negative space in between. The negative space can also be seen as shapes that carry equal weight in a composition (**A–C**). When the background is filled with a gradient, in some areas the negative shapes stand out more prominently than the positive shapes (**D**).

Repeating units in two directions may leave some large blank areas (**E**), which could be used for displaying a title or headline. The entire group of units in the composition can be repeated, with similar or different visual attributes, to create new configurations (**F**) or to add a shadow effect (**G**). We can also repeat the entire group in a different direction (**H**) or reflect it to form a symmetrical arrangement (**I**).

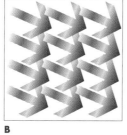

**A**

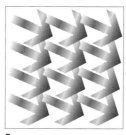

**B**

**C**

**D**

**E**

**184**

F

H

G

I

## CLIPPED UNITS IN REPETITION

A group of units can be cut and pasted inside a
clipping path, resulting in a *clipped unit* that can
be subsequently repeated to form a composition
(**A**).

To create fill that does not have gaps, the shape of
the clipping path can be square, rectangular, trian-
gular, rhomboidal, or hexagonal. A square or rect-
angular clipped unit can be repeated or paired with
a rotated or a reflected copy (**B**). A composition
with clipped units frequently shows a noticeable
grid with a trimming effect on the shapes nested
inside (**C**).

A triangular clipped unit must be repeated and
rotated to form a rhombus or a hexagon before
repeating the unit again to create a composition
(**D**). Rhomboidal shapes can be repeated across in
a row and then straight downward (**E**), or down-
ward with slight shifts to the left or right (**F**).

Shapes inside a clipped unit can be randomly
arranged (**G**, **H**), because regularity is conveyed in
the repetition of the whole unit (**I**). If the clipping
path is in a non-rectilinear configuration (**J**), or if
two or more clipping paths are grouped (**K**),
repeating such paths as clipped units can show
gaps which, however, allow us to introduce other
shapes as additional units in the composition
(**L, M**).

**C**

**D**

**E**

**A**

**B**

**186**

F

G

H

I

J

K

L

M

## BLENDING UNITS

We can easily blend units of the same configuration that have different visual attributes in a row or column (**A–D**) and subsequently use the blended group for repetition (**E**). We can blend units of different configurations and visual attributes (**F, G**) and repeat the same way in a composition (**H**).

We can blend units that contain gradient fills (**I–L**) and subsequently repeat them (**M**). After repeating the blended units, we can use regularly placed additional units to help balance the composition (**N, O**).

After blending units to attain a gradual change in proportion (**P**), we can ungroup them and move each unit manually so that their edges barely touch one another (**Q**). Compositions using this group for repetition, may suggest illusions of spatial curvature (**R, S**). We can also add further sets of blended units (**T, U**) to achieve more complex compositions (**V, W**).

E

F

G

A

B

C

D

H

**188**

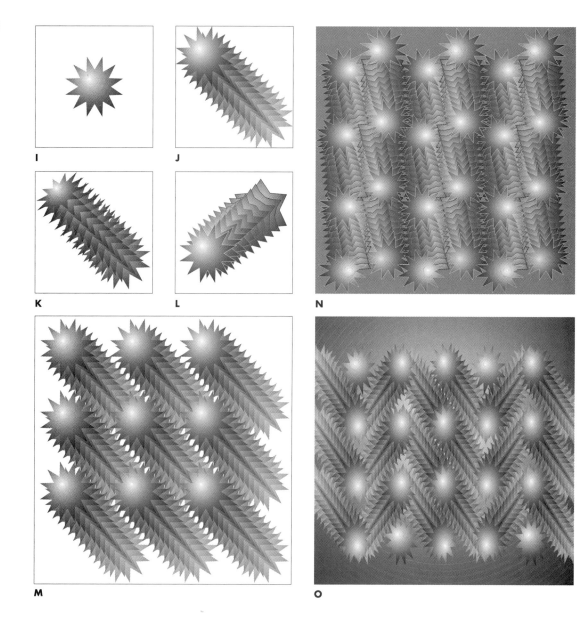

I

J

K

L

N

M

O

P

Q

T

U

R

V

S

W

## ROTATING UNITS

**190**

Units forming a row (**A**) can be grouped, cloned, and rotated 180 degrees. Two linked rows (**B**) can be grouped, cloned, and rotated again, first by 90 degrees to attain four repeats (**C**), and then twice by 30 degrees to attain twelve repeats (**D**), or three times by 22.5 degrees to attain sixteen repeats creating an evenly spread revolution of 360 degrees (**E**).

The resultant composition shows a radiating arrangement with a strong eye-catching center. The center can be a hole if the two rows of units are slightly distanced instead of linked (**F**, **G**) before grouping, cloning, and rotating in repeated steps (**H**). A wider hole results from allowing greater distance between the rows (**I–K**). For a more complex effect, we can group two or more units (**L**, **M**) for repetition in a radiating composition (**N**, **O**).

We can place more units along the periphery than at the center. Thus units in a wedge-shape configuration (**P**, **Q**) may achieve a more uniform coverage of the space (**R**, **S**).

Larger units cover up more space and may obstruct one another (**T**). In a full revolution, it may be necessary to ungroup the units so that we can bring some to the front completely unobstructed (**U**). We can also add other units on top of selected blank areas (**V**).

Arranging groups of units near the periphery normally forms a band, revealing the broad background at the center. Filling the background with a radial gradient adds circular rings of light that may complement the composition (**W–Z**).

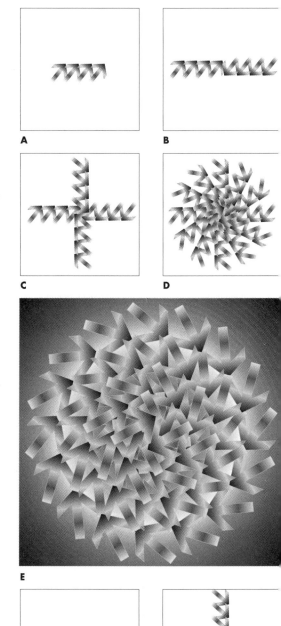

A

B

C

D

E

F

G

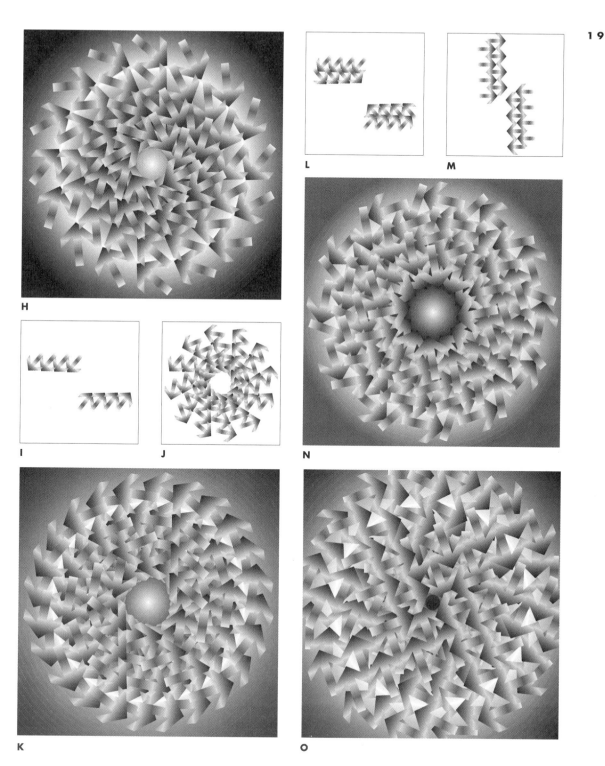

H

L

M

I

J

N

K

O

**192**

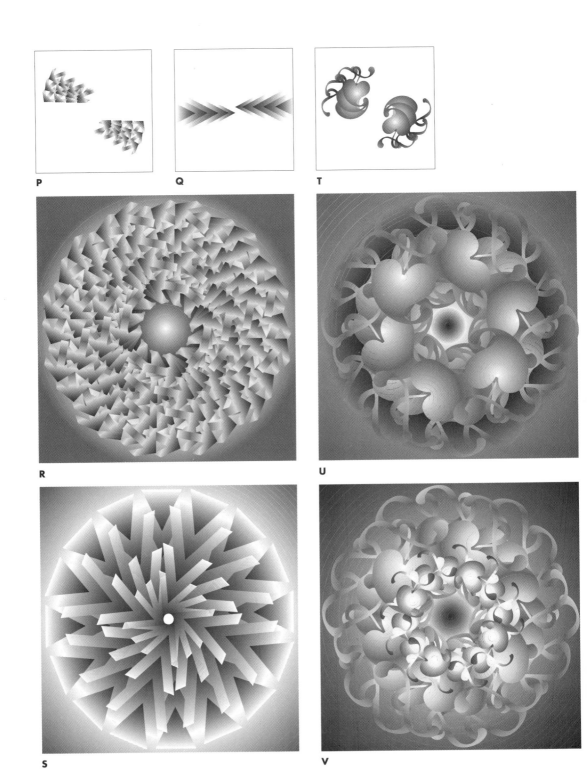

P

Q

T

R

U

S

V

**W**

**Y**

**X**

**Z**

## UNITS IN CONCENTRIC ARRANGEMENT

Units forming a band in a square or circular config-uration can be repeated with progressive resizing to attain a concentric arrangement (**A**). In this oper-ation, it is often prudent to start with a set of units in the largest desired size and reduce these in grad-ual steps, so that the smallest set appears in front with the least obstruction from other sets of units.

As we begin to resize, we can rotate the set of units at each step (**B**). Concentricity is more obvi-ous when each step of resizing creates a distin-guishable band (**C**). Rotating the sets at each step sometimes makes a spiral movement seem more prominent than the concentric movement, and the design could be seen either as a radiating arrange-ment or a concentric one (**D**).

Instead of using numerous units to form a band for concentric repeats, we can use a ring-like unit (**E**, **F**) that conveys concentric movement clearly (**G**, **H**).

Radial gradient for a fill is actually made up of innumerable concentric rings in a gradation of color or shade. Filling a shape with this type of gradient makes layers seem to merge with one another (**I**, **J**), forming sculptural configurations (**K–N**).

We can also use compound units (**O**) or interlock-ing units (**P**) to attain a concentric arrangement by occasionally changing the fills (**Q**), successively resizing and repeating (**R**, **S**), successively skewing and repeating (**T**), and by successively changing proportion and then reflecting (**U**).

**A**

**B**

C

E

F

G

D

H

196

I

J

K

M

L

N

O

P

Q

R

T

S

U

## SUGGESTED EXERCISES

**1 9 8**

All the exercises for this chapter are based on one simple shape to be used in forming compound units or groups. This shape can be created with any *shape* tool, or with a *type* tool. Our examples feature two rounded rectangles that are filled with different gradients (**A**, **B**).

**A**                    **B**

- Combine two or more shapes and send a cloned copy of the group to the back after filling it with black (**C**). Now use this larger group as a compound unit and repeat vertically as well as horizontally to establish a formal composition (**D**).

**C**

- Form a different version of a compound unit using the same basic shape (**E**) and create another formal composition (**F**).

- Blend two shapes of the same configuration and size but of different fills. Repeat the resultant column of units horizontally, then group all columns and reflect a copy vertically. Fill the background with a solid shade (**G**).

- Blend two shapes of the same configuration but of different heights. Ungroup the blend and move units so that they touch one another within the column. Repeat the column horizontally, then group all columns and reflect a copy vertically (**H**).

- Resize the columns individually to show a gradual change in width, from narrow to wide and back to narrow (**I**).

- Rotate the resultant composition slightly. Use an elongated rectangular path to clip a portion and repeat the clipped units (**J**).

**D**

**E**

F

H

G

I

**200**

- Use one column for progressive rotations to create a radiating composition. Within the column, before rotating it as repeated units, variations can be introduced by skewing, reflecting, and changing of fills (**K**, **L**).

- Use a small compound unit and progressively rotate it to form a ring. Then group the ring and successively reduce its size in regular steps, with reference to the same center, to retain a concentric arrangement (**M**).

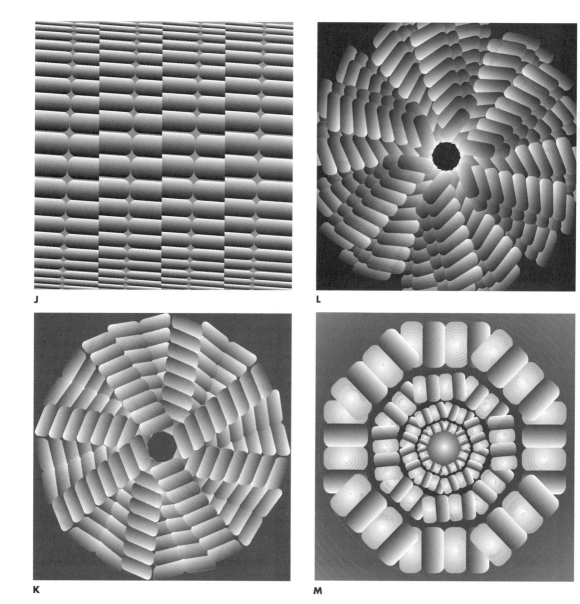

J

L

K

M

**12** SEMIFORMAL COMPOSITIONS

**202**

We can introduce a variation in the visual attributes of strokes or fills to one or more elements in a formal composition. We can also effect variation by making a change of position, direction, size, or shape.

If a variation occurs at regular intervals or spreads evenly or symmetrically throughout the design, the composition remains formal.

If the variation occurs singularly or spreads unevenly, regularity is disrupted, and the composition becomes semiformal.

Introducing one or more variations in a composition can be done to relieve the monotony of repetition, to set a focal point, or to generate accentuations.

For a semiformal composition, disruption created by variations should be kept at moderate levels. Overusing variations establishes an informal composition characterized by complete disintegration of the underlying order (the subject of the next chapter).

## VARYING THE STROKES AND FILLS

Starting with a formal composition consisting of identical shapes (**A**), we can vary the strokes, with respect to line weight and shade of one, a selected few, or all of them (**B**). We can vary the fills inside the shapes as well as in the background (**C**, **D**). Linear gradient fills can vary in direction (**E**), radial fills can vary in the position of the center (**F**), and both can have different colors or shade sequences within the fill.

We can have patterned fills that generally vary (**G**, **H**). We can use the same elements in differently shifted positions, directions, and/or scales for tiled fills (**I**, **J**). Finally filling the background with a similar tiled pattern can make the foreground merge with the pattern in an interesting way (**K**, **L**).

E

F

A

B

C

D

G

H

**204**

I

J

K

L

## VARYING THE POSITIONS

Units in a formal composition are usually arranged equidistantly, in conformity to a hidden grid, and with background evenly exposed. Varying the positions of the units breaks up the regularity of the arrangement and causes units to spread somewhat unevenly.

Starting with equidistant units containing varied gradient fills, we can move one, a few, an entire row, or an entire column, to induce irregularity (**A–D**). This may make one area in the composition particularly noticeable as some sort of focal point.

Moving units frequently exposes wider gaps between shapes, showing more of the background space, and gathers units to form concentrated groups or to relate to one another in a linear progression (**E**, **F**).

A strong focal point can be established when one single unit, or a group of densely gathered units, in a location that is not too off-center, is surrounded by wider or unbroken background space (**G**, **H**).

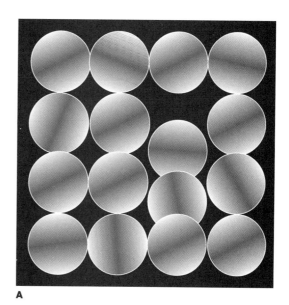

**A**

**B**

**C**          **D**

**206**

E

G

F

H

## VARYING THE CONFIGURATIONS

We can vary the proportions of shapes as units to introduce irregularity (**A**), and can use shapes of dissimilar configurations to attain semiformal compositions (**B–D**).

To alter the configuration of a shape, we can use the skew tool (**E**). We can also use distortion filters, convert points, or move points and/or handles, as discussed in preceding chapters (**F**).

Varying the configurations inevitably leads to some slight change of size. The different shapes, however, can be related to one another with fills that are similar but not necessarily identical (**G**, **H**).

E

F

G

A

B

C

D

H

## VARYING THE SIZES AND DIRECTIONS

**208**

Some draw programs display a grouped shape, as it is selected, surrounded by four black square dots bounding its four corners. If this is the case, we can drag any of such bounding dots to alter its size and/or proportion (**A**, **B**). We can perform similar changes to groups of shapes, or an entire row of grouped shapes, after they are further grouped (**C**). We can use the scale tool for this purpose, and there is a control palette for numerical entries.

Except for a flatly filled or unfilled circle, any shape can be given a change in direction. We can rotate shapes at random (**D**), as a row (**E**), or within a confined area (**F**), using the rotate tool.

We can use the reflect tool to flip a shape or a group of shapes spatially in a different direction (**G**). Square-like configurations can be rotated or reflected at right angles without change of their position (**H**, **I**). Changing the size of a shape, however, usually also leads to change of position, since the location and actual area of the shape can no longer remain the same (**J**).

A

B

C

D

E

F

G

H

I

J

## ADDITION AND SUBTRACTION

Changing the quantity of components in the units forming the composition is another way of effecting variations. To use addition and subtraction, we must have compound units.

A simple unit has only one layer. Cloning it adds a new layer of the same shape on top and changes it to a compound unit (**A**). We can have any number of layers forming a stack, with each layer individually manipulated, if desired (**B–F**). We can add or subtract layers from the stack, and effect variations to some individual layers or entire stacks to establish semiformal compositions (**G**, **H**). Stacks can be linked to form a row or a column (**I**) and repeated with further modifications in different arrangements (**J–M**).

E

F

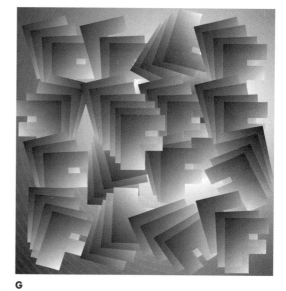

G

A

B

C

D

H

**210**

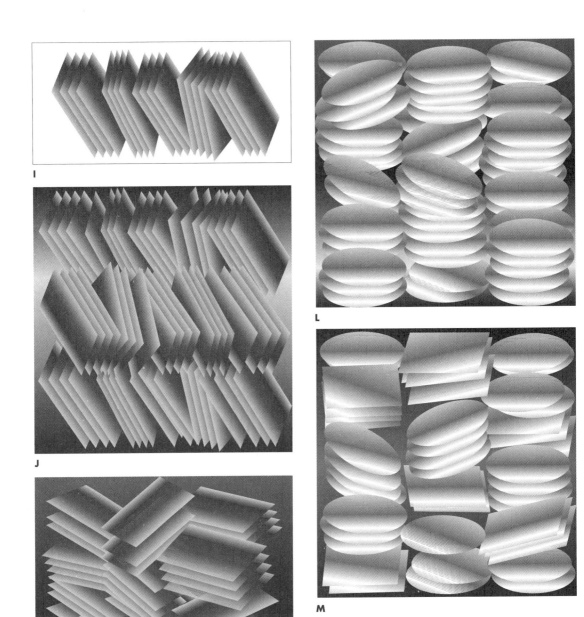

I

J

K

L

M

## MODIFYING COMPOUND UNITS

Any compound unit can be modified by changing its visual attributes, and the position and direction of individual components (**A–F**).

We can use the same compound unit, or two or more of its modified versions, to establish a formal composition, and subsequently perform necessary variations in each compound unit to attain some irregularities for a semiformal composition (**G**, **H**).

All the different ways of effecting variation discussed earlier in this chapter can be used for modifying individual compound units. Examples here generally maintain the overall regularity of a grid structure.

E

F

G

A

B

C

D

H

## USING CLIPPED UNITS

**212**

We used clipped units to establish formal composi-tions in the last chapter. Elements clipped inside a path can be moved as a group or individually. We can start with a few variations (**A–D**) before using them to establish a semiformal composition.

Using rectangular paths, we can arrange slightly varied clipped units so that they cover the entire background without gaps, showing distinct vertical and horizontal divisions (**E**). Paths in the configura-tion of triangles can be split into two right-angled triangles (**F**), and these can introduce diagonal edges as well as horizontal or vertical edges in a composition (**G**).

Clipped units can be rearranged to expose the background by deviating from a grid structure (**H**, **I**). Dividing full units into half-units gives more flexibility for covering exposed background areas in a random manner (**J**, **K**).

**E**

**F**

**A**

**B**

**C**

**D**

**G**

H

J

I

K

## USING TILED FILLS

**2 1 4**

As we have seen in the previous chapter, tiled fills inside a path (**A**) can be shifted (**B**), resized (**C**), rotated (**D**), and/or reflected (**E**). We can have more than one layer of the tiled fill in the shape (**F**), and we can have a solid shade or gradient behind the tiled fill (**G**, **H**).

These are some of the variations for altering tiled fills of individual units or shapes to create a semi-formal composition (**I**, **J**).

G

H

I

J

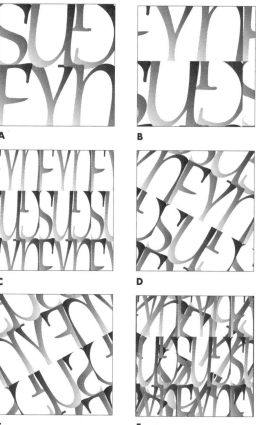

A

B

C

D

E

F

## REORGANIZING RADIATION

To alter the regularity of a formal composition fea-
turing radiation (**A**), rotated units can be repeated
to form several superimposed layers, each of which
is slightly shifted by varying the fills in the units
(**B**). Greater irregularity is achieved by further shift-
ing and resizing individual units in the reorganiza-
tion process (**C**, **D**).

Alternatively, we can shift individual units before
repeating them as layers (**E**). We can add or sub-
tract units and vary size, position, or direction of
individual units or the entire layer (**F**, **G**).

To maintain some degree of regularity, semiformal
compositions featuring rotated units should always
show an identifiable center, from which the units
diverge or to which they converge. Additional
examples here demonstrate the use of an italicized
lowercase letter *y* first paired with a 180-degree
rotated copy (**H**), then rotated in a circular revolu-
tion (**I**) and developed in the configuration of a
blooming flower (**J**–**M**).

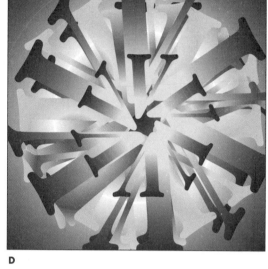

D

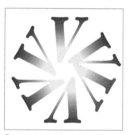

E

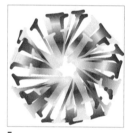

F

A

B

G

C

216

H    I

L

J

K    M

## REORGANIZING CONCENTRICITY

A formal composition featuring concentricity shows duplicated units progressively resized and superimposed upon one another without change of position. Shifting positions and directions of individual units, along with resizing, if desired, can effect irregularity in the structure (**A**, **B**). Dramatic spatial depth can easily be enhanced by adding gradient fills in the units as well as the background (**C**, **D**). The composition increases in complexity with the addition of a modified layer (**E**).

We can blend nested rectangular paths of different sizes, shapes, and directions (**F**, **G**) and reorganize intermediate steps to achieve a semiformal composition (**H**). Manipulating points on individual paths can convert straight lines to curves (**I**). Adding points to the paths can effect bending of the blended lines (**J**). If the paths are stroked but not filled, duplicating the layer and effecting changes to one or both layers can create an intriguing network of lines in the composition (**K**).

**A**

**B**

**C**

**D**

**E**

**2 1 8**

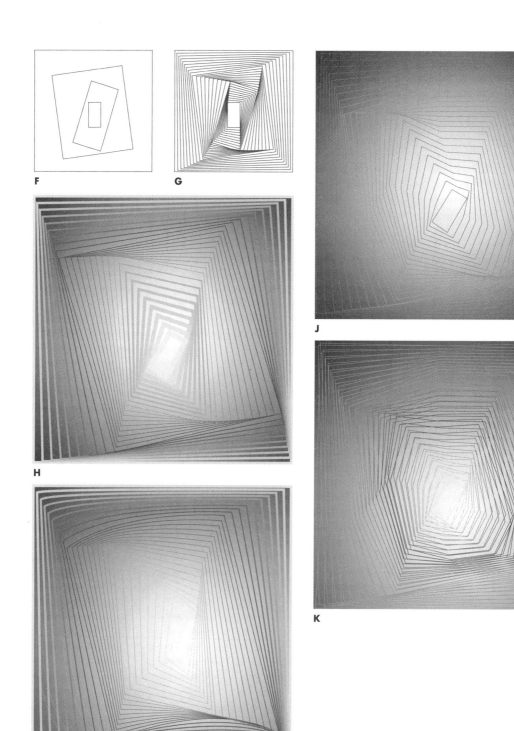

F

G

J

H

I

K

## SUGGESTED EXERCISES

To achieve semiformal compositions, we usually start with formal compositions. Variations of strokes and fills, shape, size, and proportion must be effected moderately so that some regularity is maintained. The formal composition can be established by using a simple unit based on a letter form repeated in two directions, on a background filled with a gradient (**A**). With this, you can proceed to the following exercises:

- Rotate or reflect as many units as desirable (**B**), as well as change the fills of units at random (**C**). Then change the fill of the background (**D**).

- Change the fills of the units again, individually or as one entire group, and observe the effects. Divide the background into four parts and fill each part with the same or a different gradient (**E**).

- Clone the entire group of units with slight shift of position. Now each unit is in two layers, with the back layer filled in generally darker shades, working as a shadow. Change the fills for the different parts of the background to provide adequate contrast (**F**).

- Increase the number of layers of units, from two to three or four. Change the gradient fills of each layer and the divided background (**G**). Rotate the top layer or top two layers 90 degrees and manipulate the fills again (**H**).

- Use a right-angled triangle to clip a few units (**I**). Rotate a copy of this triangle 180 degrees and the two together to establish a square (**J**). Repeat this square to form a composition (**K**). Subselect some triangles and vary the fill to introduce slight irregularity in the repetition (**L**).

- Use the same units in a group, crop them with a square or rectangle (**M**), and copy them for pasting in continuous tiled fill across the entire area of the composition. Add a new background with a gradient fill behind the transparent tiled pattern (**N**).

- Clone the layer of tiled pattern on top of the composition and change the direction of this new layer (**O**).

**220**

E

G

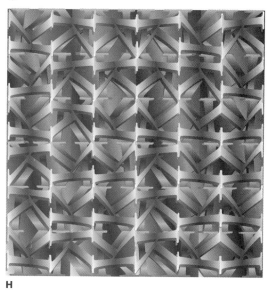

F

H

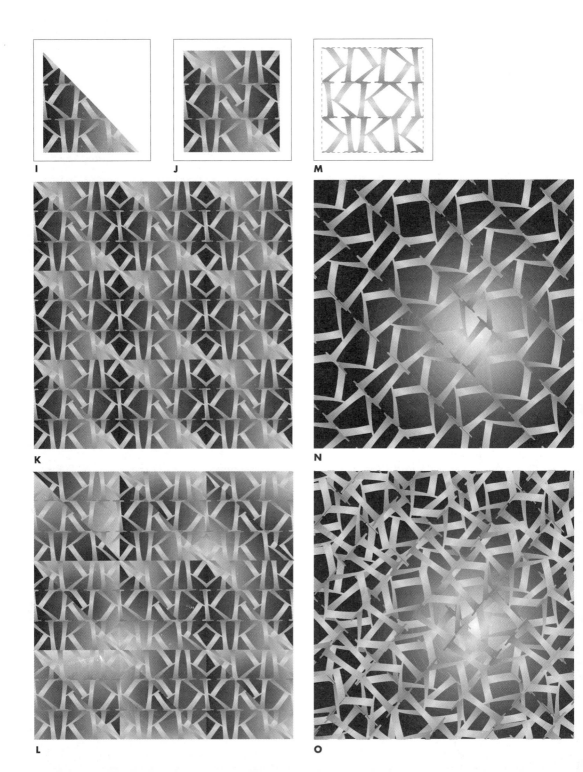

222

I

J

M

K

N

L

O

# 13

INFORMAL COMPOSITIONS

**224**

A formal composition becomes semiformal with the presence of irregularity. If we introduce a high degree of irregularity to the composition, all perceptible order is obliterated, and the composition changes to informal.

A semiformal composition shows an underlying grid structure that guides placement of elements, units, or shapes, although this pattern might be slightly affected by irregular variations. An informal composition need not suggest the presence of any underlying grid structure.

We can create an informal composition from a formal or semiformal structure by disarranging the units so that any preexisting order is no longer discernible.

We can start with units or elements that are similar or different, and arrange them so that they confront one another with their contrast in one or more ways.

There are no definite rules for creating informal compositions, but some basic principles can help us to achieve balance, harmony, dynamism, and other intended effects.

## DISARRANGING UNITS

A formal composition features orderly, positioned units (**A**) that can be disarranged to attain an informal composition by moving entire rows or columns of the units in different ways (**B–E**), or by moving individual units to new positions (**F–H**).

Disarranging the units redistributes them, so that they are closely gathered in certain areas and loosely spread out in others. An appropriate balance of mass and void, of density and sparseness should be accomplished (**I–L**).

E

F

G

A

B

C

D

H

226

I

K

J

L

## REARRANGING UNITS

We do not need any preconceived idea in disarranging units. However, we can move the units in a certain manner to achieve definite configurations. In this way, instead of disarranging them, we rearrange them with an idea in mind.

The units can be grouped into a mass that can be identified as a shape. The composition remains informal, for the units are brought together freely, and there is no strict geometrical structure (**A–H**).

We can also gather units in a linear configuration to suggest shapes of letter forms or symbols that are somewhat recognizable (**I–L**).

E

A

B

F

C

D

G

H

**2 2 8**

I

K

J

L

## CHANGING THE DIRECTIONS OF UNITS

Any shape used as units has an intrinsic direction. The circle is the only exception, but it can be flattened, elongated, or flipped spatially to assume an oval shape that can be rotated with noticeable change (**A**, **B**).

Rotating a shape changes its direction. If this does not cause significant disruption of the overall structure (**C**), then we need to effect change of direction along with change of position to establish an informal composition (**D**, **E**). If units are filled with a linear gradient, direction of the gradient can also be changed (**F**).

The units can be grouped to form specific shapes that cohere as a solid mass or any type of linear configuration. With change of direction, units can be rotated to follow the flow of a straight edge or a curvilinear bend as they are rearranged (**G–J**).

**E**

**A**

**B**

**F**

**C**

**D**

G

I

H

J

## CHANGING SIZE AND PROPORTION

Spatial illusion can be created by changing the direction of the units and further enhanced by changing size and proportion. Units can appear to be moving backward in space by reducing their size, and moving forward by enlarging them. Changing the proportion can suggest the appearance of flat objects being flipped in space.

In composing, we can first gather larger and smaller units into columns or rows and then shift the positions and directions of individual units in each column or row (**A–D**).

Units of similar sizes can be generally grouped in separate areas in the design to achieve a sense of unity (**E–G**). Units arranged in a gradation of sizes can show rhythmical progression as they form a preconceived shape (**H**).

**A**

**B**

**C**

**D**

**2 3 2**

E

G

F

H

## CHANGING VISUAL ATTRIBUTES

Units floating in space can appear lighter or heavier by changing visual attributes, particularly in the fill (**A**). Change in size and proportion makes them appear closer or more distant (**B**).

If we apply strokes without filling, each unit appears in a single outline that can vary in weight but can only be given one solid shade (**C**). To apply a gradient effect to hollow shapes, we need two concentric rings forming a composite path that can be filled (**D**). Our illustration here actually utilizes the letter *o* converted to a composite path. Duplicated paths are then varyingly filled with radial gradients to establish the composition (**E**).

B

C

D

A

E

## CHANGING CONFIGURATION

**234**

We can transform or distort units or shapes in the same configuration to attain a change in their configurations (**A–D**). We can also start with units or shapes in different configurations to constitute a composition (**E, F**).

To maintain general unity, however, dissimilar units or shapes should be restricted to two or three types, and there should be more in one type and fewer in the others. Whatever occupies a more central location establishes a focal point (**G**). We can also make rhythmical accentuations using one type that becomes more visible to enliven the design (**H**).

E

F

G

A

B

C

D

H

## DOMINANCE AND DISTINCTION

Units tend to compete with one another. When there are two or more types of units of different configurations in a composition, we may need to give one type a more dominant role. This would mean that it is greater in number (**A**), more visible (**B**), or covers more space within the frame of reference (**C**, **D**).

Units that are seen as dominating in a design are not necessarily distinctive. A focal point is often accomplished by giving distinction to one or a few units that contrast sharply with other units (**E**). Units in different configurations but related in size and visual attributes can be seen as a distinct group to form the focal point of a design (**F**).

E

F

A

B

C

D

## CONFRONTATION AND CONTRAST

**236**

Shapes or elements of different configurations but of similar size and visual attributes can be seen as confronting one another in a composition, especially when there are very few of them.

Two confronting shapes can produce slight discord when neither dominates (**A**). This is sometimes desirable when the intention is to draw more attention from viewers.

To attain some harmony, we can move the two shapes closer, to constitute a group, and darken one to contrast with the other in a lighter tone, which now gains greater visibility (**B**). We can move the two shapes even closer together, with the one in front partially obstructing the other and showing greater prominence (**C**).

Three shapes of different configurations can lessen the sense of confrontation. Whichever shape stands out in full view, with greater contrast to the background shade, becomes the focal point (**D**).

**A**

**B**

**C**

**D**

## CONTRAST OF CONFIGURATION

There are different aspects of contrast in visual situations. In creating informal compositions we need to know what these aspects are, and how to maximize or minimize them.

Contrast makes the differences in dissimilar qualities more apparent. When shapes show some dissimilarity, contrast in configuration is present and can be modulated.

Any shape is first described by its configuration. We can relate shapes by stressing their common characteristics, thus reducing contrast between them. We can confront one shape with another by emphasizing their differences, thus increasing contrast.

Configuration of shapes can be described as angular or rounded (**A**), flat or curled (**B**), geometric or organic (**C**), abstract or representational (**D**), symmetrical or asymmetrical (**E**), or simple or complex (**F**).

A

B

C

D

E

F

## CONTRAST IN SIZE AND PROPORTION

**2 3 8**

Contrast in size is seen when a small shape is next to a large shape (**A**). Contrast in proportion happens when a narrow shape is paired with a wide shape (**B**) or a short shape is positional next to a tall shape (**C**).

We can vary a shape to change its size and proportion and use different versions to establish contrast (**D**). We can also use shapes of different configurations to attain contrast in size and proportion (**E**).

**D**

**E**

**A**

**B**

**C**

## CONTRAST IN DIRECTION

Two identical shapes can show contrast in direction when one of them is rotated. We can place one in a vertical direction and the other in a diagonal direction, or we can rotate each individually in opposite directions.

Any shape in a vertical or horizontal direction usually suggests stability, whereas one in an oblique direction appears unstable. An unstable shape can be supported by a stable shape (**A**, **B**), or we can make it appear to be falling to express movement (**C**, **D**). Thus contrast in direction can also convey a contrast in stability and instability.

B

C

A

D

## CONTRAST IN QUANTITY

**240**

When there are two or more types of shapes, one type can be greater in number than the others. We can have a contrast of one and many (**A**) or less and more (**B**) in a composition. Units in larger quantity can have a dominating effect in a composition, but those in a smaller quantity would show distinction, as discussed earlier in this chapter.

When effecting a contrast in quantity, any kind of shape can be increased in number with added layers and can be varied in size, proportion, direction, and visual attributes (**C**).

A

B

C

## DISTORTION AND FRAGMENTATION

A shape can be distorted with a built-in filter in the program. We can also move individual points on the path, add or delete points, convert points, and/or move point handles to attain distortion.

Distortion may change the configuration slightly or considerably, effecting varying degrees of contrast in configuration between the original shapes and the distorted ones (**A–C**).

We can use the knife or scissor tool, or similar commands, to slice up a shape and then move, rotate, duplicate or delete the separated parts, changing visual attributes, where necessary, to create a composition (**D–F**).

Fragmented shapes can also be individually distorted, if desired (**G**).

B

C

A

**2 4 2**

D

F

E

G

## GENERAL DECONSTRUCTION

It is easy to deconstruct a formal composition (**A**) by slicing up the space inside the frame of reference into unequal subdivisions (**B**), filling each subdivision in appropriate shades or gradients (**C**), duplicating them as a layer on top, and filling this top layer with a tiled pattern that is the entire formal composition itself.

The original regular distribution of the units can be disarranged by individually varying the size and proportion as well as position and direction of the tiled fill in each subdivision (**D**).

We can explore different options by creating more subdivisions, duplicating some into multiple layers, and changing the fills for each subdivision (**E**, **F**). Formal compositions featuring radiation structures can be manipulated in a similar way to achieve general deconstruction (**G**, **H**).

B

C

A

D

**244**

E

F

G

H

## SUGGESTED EXERCISES

Convert a letter or a typed numeral into a path and fill it but do not stroke it (**A**). This operation can be repeated to form a compound unit (**B**), which is subsequently repeated to establish a formal composition (**C**). Now proceed with the following exercises:

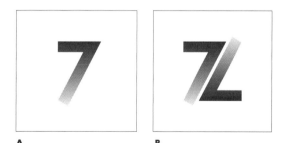

**A**                                           **B**

- Disarrange the units to attain an informal composition (**D**). Introduce changes in direction, size, proportion, as well as visual attributes (**E**).

- Slice up space within the frame of reference into unequal subdivisions and fill individual subdivisions with a gradient. Duplicate the subdivisions to form a new layer on top. Fill the new layer with a tiled pattern that features the formal composition obtained earlier. Resize and rotate the tiled fill in each subdivision on the new layer (**F**).

- Take the letter that was used to obtain the formal composition and duplicate and rotate it to form an interlocking compound unit (**G**, **H**). Duplicate this unit in varying sizes and create an additional unit, in a very different configuration, to establish an informal composition (**I**).

- Redevelop the informal composition just created with more duplications as well as changes in direction and visual attributes (**J**).

**C**

**D**

**2 4 6**

E

I

F

J

G          H

# 14

## PRINTING AND FINISHING

**248**

A computer-generated design may be intended for multiple reproduction in large quantities, for transmission on the Web, to form part of a visual expression that includes movement and sound, or as the basis for three-dimensional or environmental realization.

In most instances, the design created as an electronic image is printed on paper with a desktop printer, so that the design can be viewed away from the computer, corrected by hand, or displayed.

Our concern in this book has been the creation of designs intended as flat and still images. Such designs need to be printed on paper so that we can see our efforts in a tangible form. The monitor display may not provide adequate pixel resolution, as it sometimes renders line weights inaccurately. In addition, colors are seen differently, with different degrees of brightness and contrast, and under different lighting conditions, even on the same screen.

With technological advancement and commercial competition, desktop printers have become extremely affordable. Better results and greater speed are achieved with each new generation of these machines. Generally speaking, we are all inclined to use printed results as a standard for judging our accomplishments.

Before printing, we should organize all attempted exercises of each chapter into special layouts, add titling and descriptive text to each piece or group of work, determine formats, choose paper, and plan how the designs would appear in a final form as a leaflet, book, or package.

Then we should consider post-printing treatment that may include trimming and folding the paper, making holes and shapes with knives or scissors, gluing, stitching, and binding, and any additional finishing touches.

## CREATING A LEAFLET

Before we transfer individual designs from differ-
ent documents to one document and organize the
designs into a layout, we need to decide whether
we want to see the results as a leaflet or in some
other form.

A leaflet is a single sheet of paper, suitably
trimmed or shaped, then folded (**A–D**). Folding cre-
ates sections that can contain individual designs, or
a design can spread from one section to the next.

The overall dimensions of a leaflet are determined
by the size of individual sections and the size of
the paper to be used for printing. Paper can be
joined at section edges to create a special shape or
if the paper is not large enough for the purpose.

**A**

**B**

**C**

**D**

## CREATING A BOOK

**250**

Loose sheets of identical shape and size can be assembled to form a book (**A**). The book can be as large as an untrimmed sheet.

If we fold each sheet before assembling, the book can be no bigger than half the size of an untrimmed sheet (**B**).

Folded sheets can be nested, with the folds acting like a hinge when the assembled book is opened (**C**). In this case, we need to plan the contents for each page carefully, for a sheet will contain seemingly unrelated pages in the preparation stage.

A

B

C

**A**

**B**

## BINDING THE BOOK

Loose sheets that form pages of a book are arranged in a definite order that becomes permanent through the binding process. We can glue and/or stitch stacked paper to achieve this coherence, making the book binding part of the design.

A number of nested sheets can be stitched at the folds, making a *signature* (**A**). A number of signatures can be stacked (**B**), glued together, and placed inside a heavier folded sheet that forms the *cover* and the *spine* (**C**). Between the cover and the stack of signatures, folded sheets can be added as *end papers*, if desired.

Alternatively, folded sheets can be stacked together without nesting, a series of holes can be bored along the trimmed edge opposite the folded edge to facilitate sewing threads to bind the sheets together. Covers are added before the operation (**D**), and there is no spine.

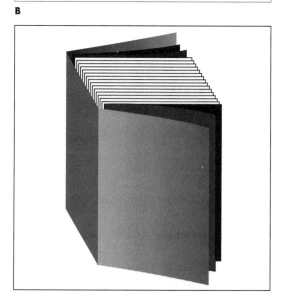

**C**

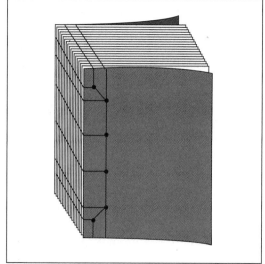

**D**

## CREATING A PACKAGE

**252**

Loose sheets, leaflets, an entire book, or a number of flat or three-dimensional items can be contained in a specially designed package.

Package designs can take many different forms. The simplest is a box with one open end, where items can be placed inside (**A**). This is suitable for loose sheets of identical size and configuration, or an entire book.

The advantage to a package with a separate lid is that items do not fall out easily when the lid is closed (**B**).

We can also create a package that is folded from one sheet of paper (**C**). This may challenge a designer's imagination. The package is first conceived as a flat shape that can be printed before cutting and folding. The folded shape needs to be structurally strong to function as a container for something loose and possibly heavy.

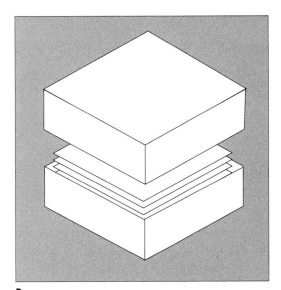

B

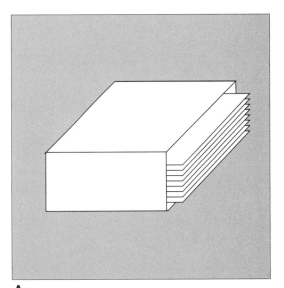

A

C

## CHOOSING PRINTER AND PAPER

Our designs can be printed in high resolution and vivid color with most machines now available. With a modest budget, an inkjet printer is more than adequate. This machine produces images in a resolution of 750 dpi (dots per inch), or even higher, on letter- or legal-size paper.

We can print designs on most types of paper. Some types of paper are specially manufactured for inkjet output. Paper comes in different weights, colors, and textures, and is available with a glossy surface for very high resolution (ideal for photographic images).

Although we can print on both sides of a piece of paper, precise alignment is usually impossible using small desktop machines. We may have to glue two pieces of printed work back-to-back (**A**). For this purpose, a non-water-based adhesive that can be spread or sprayed neatly and evenly onto the paper is recommended.

We can join two pieces of paper along a folded edge (**B**) by using double-sided tape or a kind of glue that does not curl paper.

**A**

**B**

## TRIMMING PAPER

**254**
The printing process always leaves blank margins along the edges that usually must be trimmed (**A**, **B**). A design may leave a lot of unprinted area that has to be trimmed (**C**, **D**).

Generally, the purpose of trimming is to make straight cuts that remove unwanted parts of the paper. We can use a paper trimmer or a mat knife or cutter guided by a metal ruler.

We can also use trimming to create simple rectilinear shapes—rectangles and triangles of any configuration (**E–H**), polygons with a reasonable number of edges (**I**, **J**), even semi-regular or irregular shapes as long as they have straight edges and protruding angles (**K–N**).

## FOLDING PAPER

Paper is folded along straight creases. A crease can be made with a blunt knife that scores the surface of the paper without cutting through.

After scoring, paper can be folded either inward or outward (**A**). The same piece of paper can have more than one fold (**B–D**). Instead of folding vertically or horizontally, we can also fold diagonally (**E**, **F**).

For thin paper, after folding once to form two layers, we can fold again to form four layers (**G**).

We can also score paper in a particular way so that part of the paper protrudes as it is folded (**H**).

E                                    F

G

A                              B

C                              D

H

## CUTTING SLITS

**256**

If the paper is stiff enough, we can cut through it by making a *slit* that can form part of the design. A slit is a cut that makes a linear opening on the paper surface without removing any part of the paper. Slits can be introduced on the flat paper surface (**A**) or along a fold (**B**).

We can cut several slits on the same piece of paper (**C**, **D**). We can also have intersecting slits (**E**), or slits in special shapes (**F–H**). Most slits are straight cuts, but they can be designed in a curved shape or any shape that is like an open path (**I**). A shaped slit can create a positive shape on one side and a negative shape on the other side along a fold (**J**, **K**).

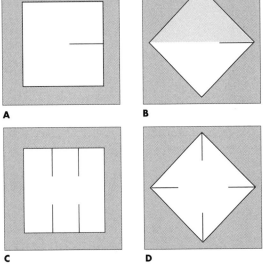

E   F   G   H   I   J

A   B   C   D   K

## CUTTING HOLES

A hole is an opening on a paper surface. The opening is accomplished with a cut that removes a confined area that has a shape of a certain size (**A**, **B**).

We can have more than one hole on the same surface (**C**). A number of holes can be arranged in a pattern-like design (**D**). Folding the paper, we can make a hole on the front layer that reveals what is on the back layer (**E**). We can also place a hole or a series of holes along the fold (**F**).

Several layers containing holes of the same configuration and size can be accurately superimposed (**G**). Holes of different configurations and sizes can be superimposed in a manner that works as a design (**H**).

**E**          **F**

**G**

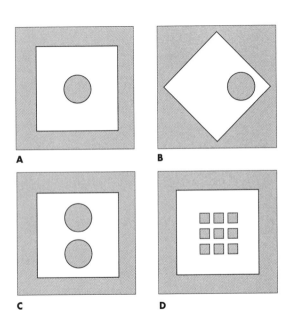

**A**          **B**

**C**          **D**

**H**

## SHAPING CORNERS AND EDGES

**2 5 8**

Trimming edges produces straight cuts, effecting sharp corners and straight edges. Die-cuts are used by commercial printers to shape corners and/or edges in special ways. We can use a mat knife or a pair of scissors to do this manually.

Any corner can be rounded (**A**). We can introduce a positive shape (**B**), a negative shape (**C**), or a combination of positive and negative shapes (**D**) along any edge. We can reshape entire edges (**E**, **F**). Complicated shapes can be introduced along an edge, with portions hanging out, if the paper is strong enough (**G**, **H**).

Specially designed shapes on edges can form a lock when the paper is folded and the opposite edges interconnect (**I**, **J**).

E

F

G

H

I

A

B

C

D

J

## OVERALL SHAPING

Paper can be in any configuration that suits our design. It can be circular (**A**), shaped like a new moon (**B**), or in a series of linked shapes (**C**). Linked shapes may have holes in between (**D**).

We can have linked shapes arranged in more than one direction (**E**). If we do not have paper large enough for this purpose, we can join separate pieces at certain edges.

If all the linked shapes are identical in size and configuration, folding will produce a multilayered single shape (**F**).

**D**

**E**

**A**

**B**

**C**

**F**

## ORGANIZING A LAYOUT

**260**
If exercises are of the same size, orientation, and configuration, they can be arranged as units on one single sheet of paper or placed on separate pages of a leaflet or book.

There are software programs for layout designs, but a draw program is usually adequate for simple jobs. We can copy each design and paste it individually onto a new document that defines the final trimmed shape of the paper. Each design can be resized and organized in some desirable order. We can arrange the designs closely in a row, a column, or a grid (**A–E**), and we can spread them in a staggered way (**F–H**).

If the final trimmed shape has a special configuration, the layout must position the images in proper locations to work appropriately with all edges, corners, folds, slits, or holes (**I**).

**B**

**C**

**A**

**D**

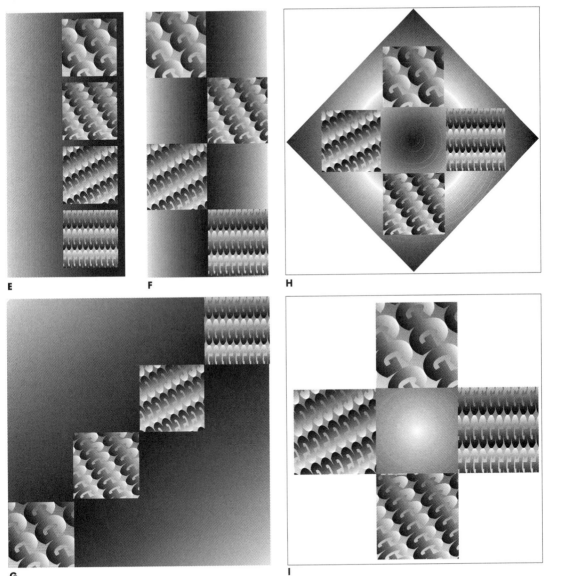

E

F

H

G

I

## ADDING TITLE AND NUMBERS

262

A title can be added on the same paper surface containing the printed designs, or on a separate sheet or page. The presence of a title identifies the contents to any viewer or reader and establishes page orientation.

Using a separate sheet or page, we can have the title as a single line in one color (**A**, **B**) or more than one color (**C**). The line of type can be diagonally or even vertically placed (**D**, **E**). If there are two words, they can form two lines, flush left or right (**F**, **G**). We can break a longer word into two lines, if necessary (**H**).

We can produce an embossed effect by using type in two superimposed layers of different colors or gray shades (**I**). Adding an identifying number helps to show sequence of sections, chapters, pages, or other references in a set of loose sheets or leaflets or within a package, and the line of type may be repeated as a design element (**J**).

FORMAL COMPOSITIONS

**A**

FORMAL COMPOSITIONS

**B**

FORMALCOMPOSITIONS

**C**

FORMAL COMPOSITIONS

**D**

FORMAL COMPOSITIONS

**E**

FORMAL COMPOSITIONS

**F**

FORMAL COMPOSITIONS

**G**

FORMAL COMPO-SITIONS

**H**

FORMAL COMPOSITIONS

**I**

**J**

## SUGGESTED EXERCISES

At this stage, all completed exercises should be reexamined. Some of them might need to be redone. The following points should be considered when organizing them into layouts for printing.

- Decide on the general format for presentation. Will the printed results be in the form of single sheets, a set of folded leaflets, or a bound book?

- What is the size of trimmed sheets, folded leaflets, or the book? What size of paper will be used? Where are the joins to link separate pieces of paper together?

- Printing is normally done on one side of the paper. For showing printing on two sides, two printed sheets must be glued together. How will you glue the two sheets?

- Will there be a containing package for the loose items or the book? How is the package to be constructed?

- A layout may have designs in rows, columns, or groups, which may be fitted in sections between rules or folds. A leaflet may have divided areas that are not rectangular. How will the designs be placed?

- It is desirable to have a title for each sheet of a leaflet. A title may be placed next to a group of designs or on a separate page or sheet. If on a separate sheet, where will it be positioned? Will there be a background for the title? Will there also be numbers to show the order in a sequence?

- What kind of paper will be used? Will you use only one kind of paper? Will you choose paper that is not white?

It may be necessary to try different layouts and to print, trim, and probably fold sample sheets in order to observe the effects.

## PURSUING FURTHER DEVELOPMENT

**264**

This book provides only a basic foundation for creating computer-generated designs. The concepts and techniques that have been discussed here offer a starting point for further exploration. To pursue development as a designer, the reader must look into the functional aspects of design, which can encompass one or more of the following:

- Conveying information
- Communicating a persuasive message
- Selling a product or a service
- Targeting a specific sector of the community
- Efficient fulfillment of a particular purpose
- Economic means of production

Designs may be created in such categories as posters, advertisements, book covers, logos, or brochures and have definite practical applications. They are probably judged more on how they meet business requirements or fulfill commercial aims than on their aesthetic merits. While our designs are here produced only for the desktop printer, they may eventually be commercially printed in large quantities.

When you are working with the computer, the need for a wider range of software programs will grow with time. Programs that are in current use may require periodic upgrading to take advantage of new and extended features.

With increased experience and proficiency, any computer user may, sooner or later, have to look into acquiring more peripherals and installing additional memory chips and accelerators in the central processing unit to gain convenience and to improve speed and performance. In time, we all have to consider replacement of the entire computer system as major technological breakthroughs occur.

Finally, however, one thing must be made clear: good design can be created with or without the help of the computer. The computer, after all, is only a tool. It is the means, but not the end. Although the computer may help realization of the idea and facilitates quick visualization of alternative compositions, what is far more important is the idea that determines the design, and the designer's aesthetic sensibility that guides the composition.

GLOSSARY

**Ascender.** Portion of a lowercase letter extending above the general height.

**Attribute.** Visual appearance of a line or shape that can be assigned with computer commands.

**Axis.** An imaginary straight line that crosses the middle of a shape, dividing it into two halves, each being the mirror image of the other; or an imaginary straight line along which a shape is reflected.

**Baseline.** Invisible line on which all letters stand.

**Bit.** The basic unit of information, in the form of a tiny square dot constituting a visible image on the computer screen.

**Bit-mapped image.** Image displayed on the computer screen, composed of bits arranged in a grid.

**Blend.** Group of sequential lines or shapes showing gradual changes, obtained with a command.

**Cap.** Shape present at or added to the beginning or ending of a line.

**Character.** Letter, number, or symbol, obtainable with the keyboard; or any basic component of our written language.

**Clipping path.** A closed path used to crop any line, shape, or image it overlaps.

**Clone.** An exact copy of a line or shape placed directly in front of the original.

**Closed path.** A path that makes a complete enclosure, containing no end points.

**Color scheme.** A set of chosen or premixed colors for use in a composition.

**Command.** A predefined operation within a software program available to the computer user.

**Composite.** A group of shapes joined together, taking on the same attributes and frequently showing holes where the shapes overlap.

**Composition.** The total visual effect of lines and shapes in specific attributes, locations, orientations, interacting with one another on a background.

**Concentricity.** Sequence of shapes arranged with reference to a common center, in coinciding layers, usually showing increase or decrease of size based on the same configuration.

**Configuration.** General appearance of a shape described by its contours.

**Contrast.** Any difference that helps us to distinguish elements, components, lines, or shapes.

**Control handle.** A floating handle associated with a point, used to adjust the curvilinearity of a path.

**Control palette.** A box displayed on the monitor screen containing information related to a selected point, line, shape, or type, as individual element or group, that can be altered to effect instantaneous visible changes.

**Corner point.** A kind of point acting as a hinge at the join of two paths.

**Curve point.** A kind of point effecting a smooth flow, removing angularity at the join of two paths.

**Cursor.** A shape in the configuration of an arrow or any appropriate symbol that can be moved by dragging the mouse to perform specific tasks on the computer's monitor screen.

**Deconstruction.** Breaking up a structure with partial or total demolition of its spatial order.

**Descender.** Portion of a lowercase letter extending below the baseline.

**Dialog box.** A message box displayed on the monitor screen that conveys or requests information from the computer user.

**Die-cut.** Slits, holes, or special shapes made on the surface or edge of paper during the printing process.

**Disfiguration.** Deforming or disintegrating a shape.

**Distinction.** Conspicuous presence of a line or shape, usually marking the focal point in a position.

**Division.** Splitting a shape into two or more separable parts.

**Dominance.** Overwhelming presence of a shape or a group of shapes occupying the biggest area of space in a composition.

**Dot.** A tiny, visible shape, usually in a simple configuration.

**Dpi.** Dots per inch, a unit measurement for screen display and printing resolutions.

**Edge.** Border of a line or shape.

**Element.** Point or path constituting a line or shape.

**End.** The starting or terminating part of a line.

**End point.** A point marking the starting or terminating part of a selected path.

**File format.** A standardized way of storing visual documents in the computer for future use or for further manipulation.

**Fill.** Color, shade, gradient, pattern, or texture that occupies the space enclosed by a closed path; one of the attributes of a shape.

**Font.** A collection of type in a specially designed style.

**Form.** Any visual entity that seems to assume independent physical existence in space.

**Formal composition.** Regular arrangement of lines or shapes with predictable repeats of individual elements or groups.

**Frame of reference.** Border defining the area and shape of a composition.

**Gradation.** Gradual sequential change in one or more visual or spatial aspects.

**Gradient.** A fill showing gradual tonal or color changes.

**Grayscale.** Range of gray shades as percentages of black.

**Grid.** Non-printing lines or dots in a regular pattern to help arrange shapes in a formal composition.

**Guide.** Vertical or horizontal line that can be dragged from a vertical or horizontal ruler displayed near the border of a document window in a graphic program to help positioning of elements.

**Hairline.** A line of 0.25-point thickness, representing the lightest preset weight obtainable with a draw program.

**Halftone.** Dot or line pattern used in printing to represent flat tints or gradual changes in colors or shades, particularly in the reproduction of photographs.

**Illusion.** Depth, volume, or spatial curvature that seems to exist on the flat surface of the paper containing the design.

**Image.** Any visible entity, whether clearly seen or barely discernible.

**Informal composition.** Arrangement of lines or shapes without a noticeable structure.

**Join.** Junction of two paths showing a protrusion.

**Layer.** Overlapping arrangement of shapes, with one in front of or behind another, making a spatial sequence.

**Layout.** An arrangement of visual elements, such as type, lines, and shapes, in graphic design.

**Legibility.** Clarity; ability of type to communicate without difficulty.

**Letter.** Individual character that forms part of a word.

**Line.** A path that becomes visible after stroking with weight as well as color, shade, or pattern.

**Location.** Position of an element, line, or shape inside the frame of reference.

**Negative shape.** A shape that is seen as a hole or gap with the background showing through.

**Object.** Line or shape that can be selected individually in a draw program.

**Open path.** A path that does not enclose space and that has two unconnected end points.

**Orientation.** General direction of a line or shape.

**Outline.** A closed path that becomes visible after stroking with weight as well as color or shade, representing the contour of a shape.

**Path.** Straight or curved linear linkage between adjacent points. This becomes a visible line upon stroking with weight and color or shade.

**Pattern.** Regularly repeated dots or lines that can cover a line or shape as part of its attributes.

**Picture plane.** An imaginary plane defined by a frame of reference, coinciding with the physical surface of the paper or screen displaying the lines or shapes.

**Pixel.** Picture element, each one representing a bit to construct a bit-mapped image on the screen display. There are 72 pixels to a linear inch.

**Plane.** Surface filled with a color, shade, gradient, pattern, or texture, enclosed by a closed path.

**Point.** An anchoring element used to determine the position of different parts of a path, with a constraining effect to its shape. It is also a unit (72 points to an inch), used in measuring type sizes and line weight.

**Position.** General location of a line or shape.

**Positive shape.** A shape that occupies space, usually blocking any other shape lying behind.

**Power duplication.** Progressive repetition of an operation by the computer, combining position and possibly other changes.

**Radiation.** An arrangement of lines or shapes that rotate sequentially around a common center.

**Raster.** The horizontal pattern of lines forming the image on the computer or television screen, or the desktop printer.

**Reflection.** Flipping to change a shape to its mirror image.

**Repetition.** Duplication of lines or shapes, usually equidistantly in a sequence.

**Resolution.** Degree of fineness or coarseness in screen display or in printing of computer-generated lines, shapes, or images.

**Rotation.** Change in orientation of a line or shape.

**Scale.** Size and proportion of a shape.

**Semiformal composition.** Arrangement of shapes with slight deviation from a regular visual order.

**Shade.** The level of brightness in a color; often referring to a gray that represents a tint of black.

**Shape.** Any distinguishable visual entity composed of paths.

**Size.** Relative length or area of a shape, or its measurable dimensions.

**Stroke.** Independent line or outline of a shape assigned weight as well as color, shade, pattern, or texture.

**Structure.** Order of arrangement that produces strict spatial regularity.

**Texture.** Dots, lines, or tiny shapes spreading evenly or unevenly over a surface.

**Type.** Any character originated with the keyboard.

**Unit.** Line or shape used repeatedly.

**Visual attributes.** Visual characteristics of a line or shape, including its general configuration, size, line weight, and color.

**Visual order.** A state of regularity achieved by relating shapes both visually and spatially.

**Weight.** Visible thickness of a line.

**X-height.** Height of type measured from the baseline to the top of lowercase letters, excluding ascenders and descenders.

I N D E X